Belleville Public Library

3 1000 00274078 8

W9-BLH-852

Mother *and* Child Portraits

Techniques for
Professional Digital Photographers

NORMAN PHILLIPS

AMHERST MEDIA, INC. ■ BUFFALO, NY

BELLEVILLE PUBLIC LIBRARY

Check out Amherst Media's blogs at: http://portrait-photographer.blogspot.com/
http://weddingphotographer-amherstmedia.blogspot.com/

Copyright © 2010 by Norman Phillips.

All photographs by the author unless otherwise noted.

Front cover photo by Vicki Taufer. Back cover photo by Jeff and Kathleen Hawkins.

All rights reserved.

Published by:
Amherst Media, Inc.
P.O. Box 586
Buffalo, N.Y. 14226
Fax: 716-874-4508
www.AmherstMedia.com

Publisher: Craig Alesse
Senior Editor/Production Manager: Michelle Perkins
Assistant Editor: Barbara A. Lynch-Johnt
Editorial assistance provided by Sally Jarzab, John S. Loder, and Carey Maines.

ISBN-13: 978-1-58428-262-4
Library of Congress Control Number: 2009903897

Printed in Korea.
10 9 8 7 6 5 4 3 2 1

No part of this publication may be reproduced, stored, or transmitted in any form or by any means, electronic, mechanical, photocopied, recorded or otherwise, without prior written consent from the publisher.

Notice of Disclaimer: The information contained in this book is based on the author's experience and opinions. The author and publisher will not be held liable for the use or misuse of the information in this book.

Contents

DEDICATION

Choosing to dedicate a book to someone special is not an easy or simple decision. There are many reasons why an individual might be worthy of such a dedication, and to relate all of them here would take up a great deal of space. So, to keep it simple, I am dedicating this book to the mother of my three adult sons, my wife Sandra.

For more than forty years, I have observed Sandra nurture and emotionally counsel our three boys as only a mother can, sometimes almost intrusively because of her concern for their well being. As they became adults, they frequently resisted these overtures, as "children" in their late teens and twenties will do. Sandra has never faltered. She is blessed with gifted sons who have a wonderful sense of humor, and she has responded to their reactions with wonderful smiles and laughter.

The memories are precious and create a warm glow as I recall the countless moments of a mother's undying love for her children. No matter the age of a child, whether they are married or parents themselves, they are always Mother's children.

ACKNOWLEDGMENTS

The images that appear in these pages were created by some of the most accomplished professionals in the industry, and I am appreciative of their willingness to be included in this special book. Thank you to Joanne Alice, Michael Ayers, Michael Barton, Veena Cornish, Jody Coss, Kerry Firstenleit, Sarah Johnston, Jeff and Kathleen Hawkins, Mark Laurie, Cindy Romano, Sheila Rutledge, Terry Jo Tasche, Vicki Taufer, Edda Taylor, and Wendy Veugeler.

Dr. Charles Frank is another person who has been of great help. His attention to the severe arthritic and mild carpal tunnel pain in my right hand has enabled me to meet my publisher's schedule. Without him, I might not have completed this book on time.

Introduction

Ever since I was able to recognize and understand the relationship between a mother and her child, I have been captivated by the unique relationship. It is indisputable that this mother and child relationship is more compelling than any other human relationship. Capturing emotional moments between a mother and her child has been one of the most rewarding aspects of my photography career.

Throughout this book, we will see mother and child portraits in various styles, some traditional and some contemporary, some completely out of the box. The stark contrast in styles is due to the nature of those who created the images and their approach to portraiture. The images are instructive and inspiring and offer ideas and techniques that you can use as a guide to your own work, or as a base from which to start in one of photography's most challenging disciplines.

A GROWING TREND

Mother and child portraiture has become increasingly popular with families who traditionally had been most concerned to record the growth of their children. Before this style of portrait became a growth element in the portrait market, moms simply brought their off-

spring to the studio for their annual or semiannual portrait. In a majority of cases, these portraits dropped off as the children went to school and the school photographer took over.

As photographers became aware of an unexploited market for children's portraits, the smart operators projected family portraits that went beyond images that included all the family and marketed portraiture

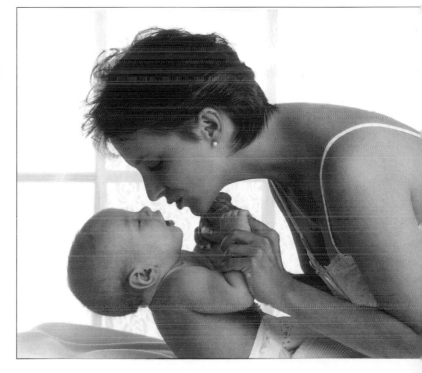

that incorporated groups of family members, such as Mom and Dad together, and then additional subgroups. This philosophy worked well when Dad was available, limiting the potential for a wider coverage of the family.

Professional photographers began creating mother and child portraiture in the late 1980s and the emotional appeal inherent in the images helped to propell the genre's popularity. My own studio entered this market with the image shown on the previous page. When the portrait was displayed in our studio window, it created a sensation, drawing crowds of viewers from all around the community. It instantly created a new market for the studio.

Before this portrait, most moms required a lot of persuading to have portraits made with their baby. Many a woman complained that she needed to lose weight post-pregnancy, or she needed to have her hair and makeup done and did not have the time. All she wanted was to have the baby photographed. But by creating the right environment, plus carefully selected props and backgrounds, moms began to get into the swing of it. This was often the result of Father's Day portrait promotions. Mother and child images were perfect gifts for Dad.

By the mid 1990s, mother and baby portraits were a regular source of income for the progressive studio, and it has since been a developing discipline among photographers who are seeking to produce images that are different, exciting, emotional, and otherwise appealing.

ABOUT THIS BOOK

So what we have in this book is a vastly diverse collection of images that express each photographer's concept of what the mother and child bond represents. As we progress through this book, we will cover pregnant moms with their children, then the tiniest of babies, and work our way through the age groups. We cover groups of children with Mom too. We also have a chapter that deals with extended sessions that offer potentially greater sales volume.

Traditional and Contemporary

If we look back into the history of portraiture, we see evidence that ideas about what constitutes an appealing portrait have changed. As mother and child portraiture is a new genre, we can expect to see the images that are produced change to reflect relevant trends as well.

In plate 1.1 (photo by Wendy Veugeler) and plate 1.2 (photo by Michael Ayers) we see two images that differ dramatically. In plate 1.1, the baby is nude. In plate 1.2, the baby is clothed in a relatively conventional style. One image is in black & white, and the other is in color. The first image has a more traditional

Left—Plate 1.1. **Right**—Plate 1.2.

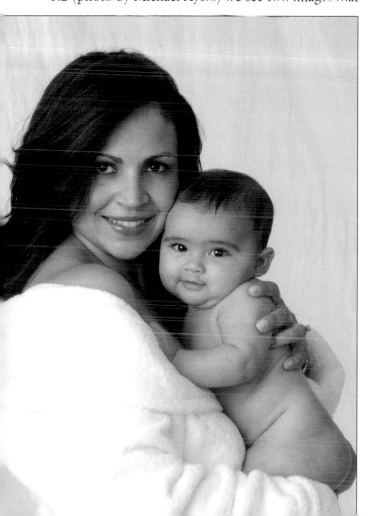
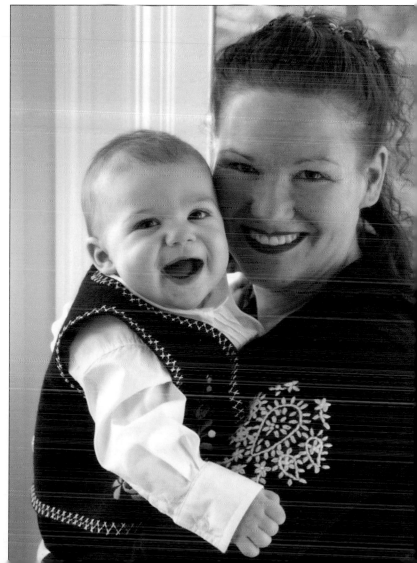

feel, and the second is more contemporary. There is a market for both styles, and photographers must consider their market before promoting one or the other.

Now look at plate 1.3. In this image, Sarah Johnston sought to create a more emotional connection between the mom and baby, and she did it well. The tones and tight cropping give the image a more modern feel, though it clearly shares some of the more traditional characteristics of the image in plate 1.1.

In plate 1.4 (photo by Norman Phillips), we see yet another distinctly different image. The subjects were photographed at the client's home. It is far different from the image shown in plate 1.5 (photo by Mark Laurie). Both images are traditional but each will appeal to a different clientele.

The portrait in plate 1.6 (photo by Vicki Taufer) is contemporary. Plate 1.7 (photo by Jeff and Kathleen Hawkins) depicts another style that came of age in the

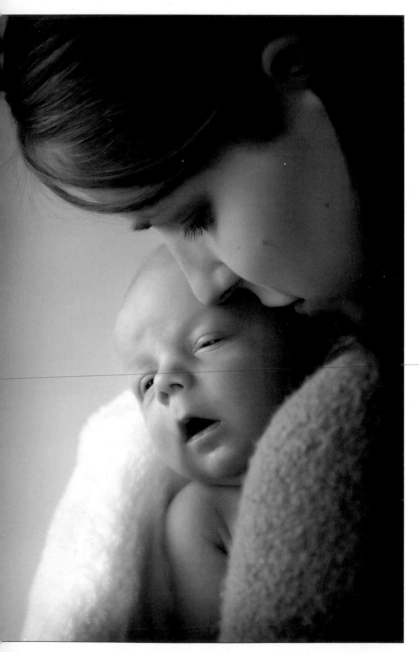

Left—Plate 1.3. **Top right**—Plate 1.4. **Bottom right**—Plate 1.5.

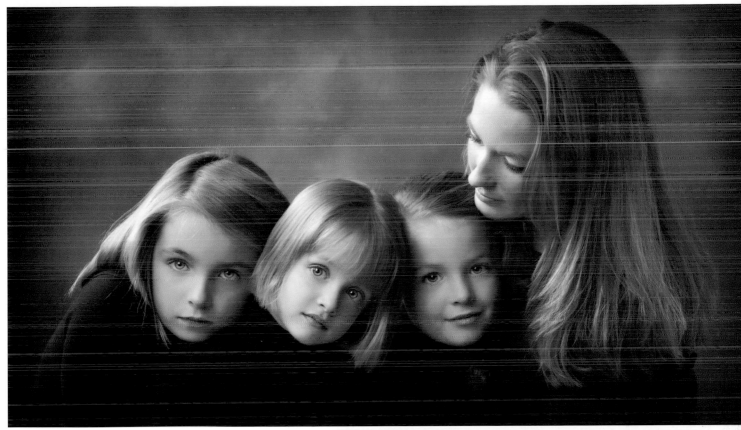

Top—Plate 1.6. **Bottom** Plate 1.7.

late 1990s when the casual portrait transcended the traditional.

Photographers either create their own style or mimic that of others. The former seek to produce images that are creative and appeal to a different segment of their market. The latter seek an opportunity to enter the market by producing images in an accepted and popular style.

As we proceed through the book, we will see images that can be classified as traditional or contemporary. Though many of the images are somewhat similar, all have a unique appeal, and as you review them you can decide which ones appeal to your concept of mother and child portraiture.

Regardless of any personal preference, the one thing that is illustrated in the images in this book is that there is no relationship more compelling than that between a mother and her child.

Pregnancy Portraits

There is an emerging style of portraiture that is becoming quite popular: pregnancy photography. These portraits are made in varying styles, and often the subjects, late in their pregnancy, are posed seminude to show off their rounded form.

In plates 2.1–2.4 (photos by Norman Phillips), we see the expectant mother in repose. The rose was placed on her belly to symbolize the flowering of life. I wanted to create a feeling of total calm before I added her little girl to the portrait (see plates 2.2 and 2.3). These two images were the first in a storytelling sequence of four. They show the curiosity and anticipation of a child looking forward to having a new baby in the house. As you can see, the theme was further developed in plate 2.4.

The main light for this series was a single-diffused 28x42-inch Recessed Westcott Apollo positioned at the left of the camera and in line with the mother. The bottom edge of the light was positioned 24 inches

Below—Plate 2.1

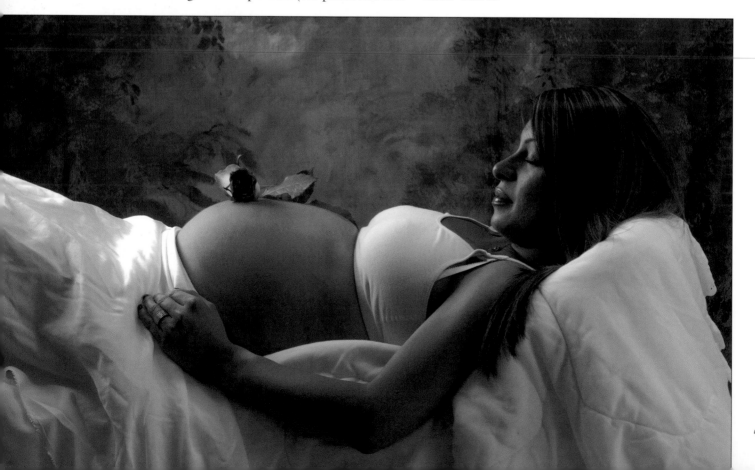

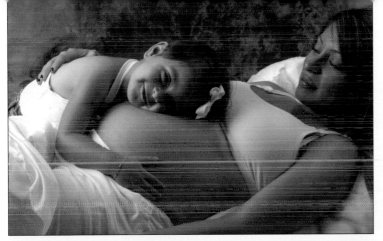

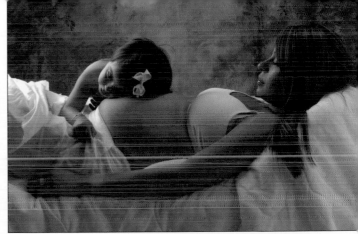

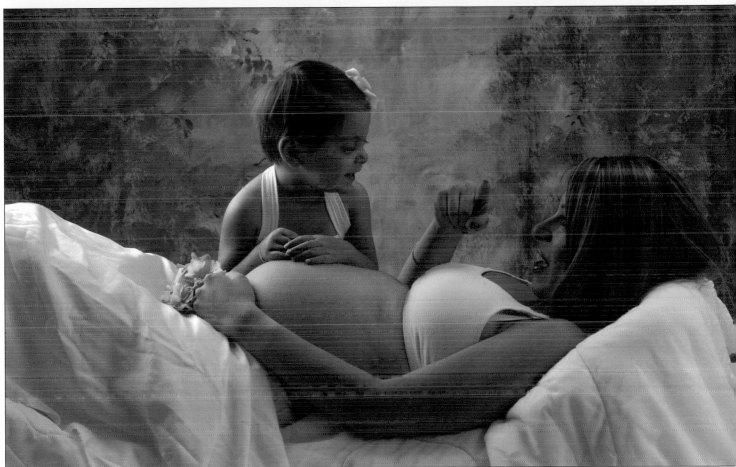

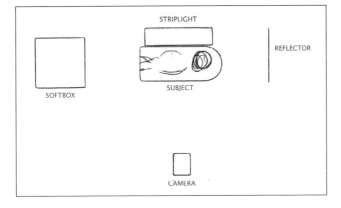

Top left—Plate 2.2. **Top right**—Plate 2.3. **Bottom**—Plate 2.4. **Right**—Diagram for plates 2.1–2.4.

above the mother's feet in order to fully illuminate the set. A reflector panel was placed 24 inches behind the mother's head to light her hair. A single-diffused 12x36-inch Westcott Stripbank was positioned 6 feet above but slightly behind the subjects. The white material in the set and in the subjects' attire helped to produce adequate fill light. See the diagram at the left.

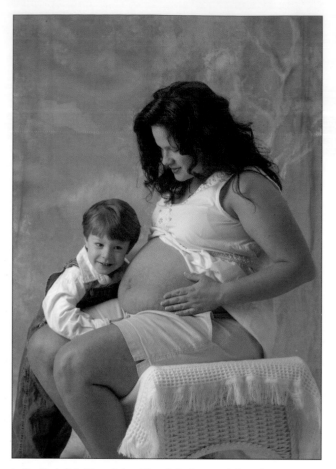

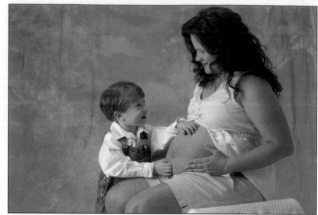

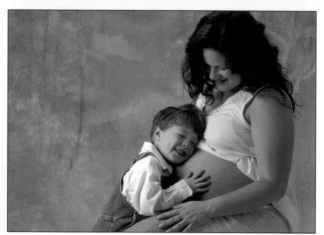

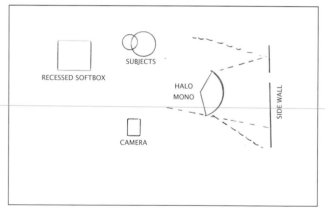

Left—Plate 2.5. **Top right**—Plate 2.6. **Center right**—Plate 2.7. **Bottom right**—Diagram for plates 2.5–2.7.

For the next series of images (plates 2.5–2.7, also by Norman Phillips), I wanted to produce an image that, once again, showed the curiosity of the child at the impending arrival of a sibling. The mother was positioned almost profile to the camera to allow her son to move around and be available to the camera. A softly mottled backdrop was used, resulting in a lower-contrast scene. This background was a good option because the little boy was active and moved around quickly.

In this sequence, the main light was again a single-diffused 28x42-inch Recessed Westcott Apollo. The light was placed at camera left and slightly feathered so that it would also illuminate the background. Light from a Westcott Halo Mono was bounced off of the wall at camera left and, positioned midway between the camera and the subjects, added fill light. See the diagram above.

The image shown in plate 2.8 (photo by Sarah Johnston) was shot on a high-key set, but without the background lights, the backdrop was rendered a light gray. The main light was a large softbox at camera left. It was positioned so that it skimmed across the front of the subjects, creating a ratio slightly greater than

3:1 on the mother's left arm. The white walls, attire, and fabrics reflected light throughout the set, so no additional fill light was needed.

Sarah did not try to capture the child's curiosity when creating this beautiful shot; she simply depicted the affection between the two subjects. By having the mother resting on her right hand, she brought her to a position that allowed her to interact with her child in a natural manner.

Plate 2.9 (photo by Veena Cornish) presents a very different view of the mother and child. The camera angle is very innovative, and I personally would never have thought of using such an approach. The high angle and diagonal composition give the image a certain pizzazz, and the light on the child is out of the box. The image breaks numerous traditionally held rules—the most striking of which is the diagonal composition—but it works to create a more dynamic photograph.

To create the image, Veena used a high-key set. Once again, no background lights were employed. The lighting setup used for this image was almost identical to the one Sarah Johnston used. The longer light ratio produced a degree of contrast that is unusual for this type of portrait. Note too that the mother's tummy is brighter than the child's face. See the diagram below.

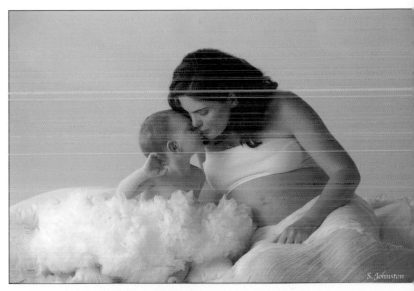

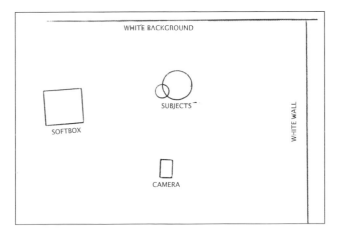

Top right—Plate 2.8. **Bottom right**—Plate 2.9. **Above**—Diagram for plate 2.9.

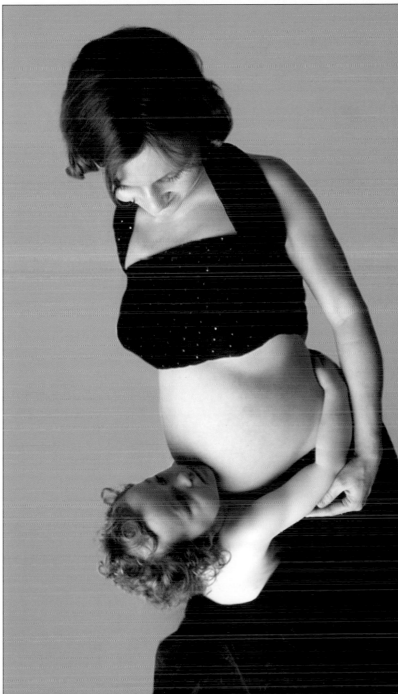

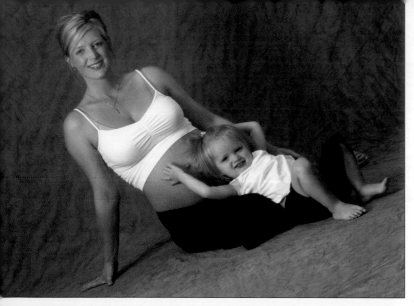

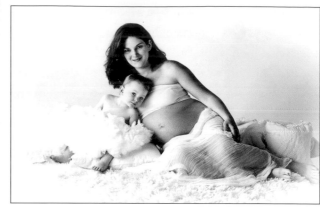

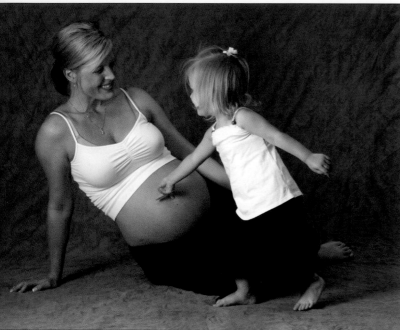

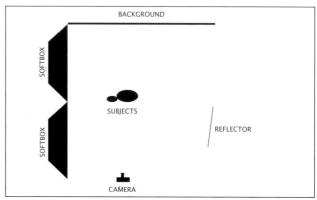

Michael Ayers is well known for his use of exaggerated camera angles, and in plate 2.10, we see an example of this style. He had the little girl lie between her mom's knees and reach back to her mom's tummy. Her expression is delightful.

Michael generally uses only two lights and sometimes a reflector. Here he used a softbox at camera left and an umbrella suspended from the ceiling behind the camera as a fill source.

In plate 2.11, Michael used the same lighting setup but chose a conventional camera angle. The little girl is engaged with her mom and is focused on her tummy. The image has an interactive feel. It is straightforward and uncomplicated. See the diagram for plates 2.10 and 2.11.

Plate 2.12 (photo by Sarah Johnston) shows a mother and child posed in a triangular composition with the child's head at her mom's shoulder. Sarah used fabric to cover the child and to add softness around the base of the portrait.

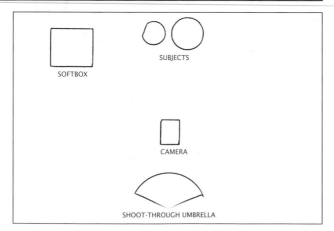

Left—(top) Plate 2.10. **(center)** Plate 2.11. **(bottom)** Diagram for plates 2.10 and 2.11. **Right—(top)** Plate 2.12. **(bottom)** Diagram for plate 2.12.

Sarah employed an unusual lighting set. She used a 4x6-foot softbox as a main light and placed an identical 4x6-foot softbox on the same side as an accent light. The reflector placed to the right of the camera helped light the backdrop and slightly reduced the deep shadows to our right (see the diagram for plate 2.12). This produced a near split lighting concept, with strong shadows to the right and soft overall illumination at the left. The effect is a dark leading line that runs from the mother's hand up and around her shoulder and hair. The baby is framed by her mom's dark hair and the shadow from her head. It is an interesting effect—a subtle contradiction of advocated lighting technique in which one side of the portrait is lit with very low contrast and the other with strong contrast.

Wendy Veugeler's portrait in plate 2.13 showcases a unique posing concept in which the child's body is

Below—Plate 2.13.

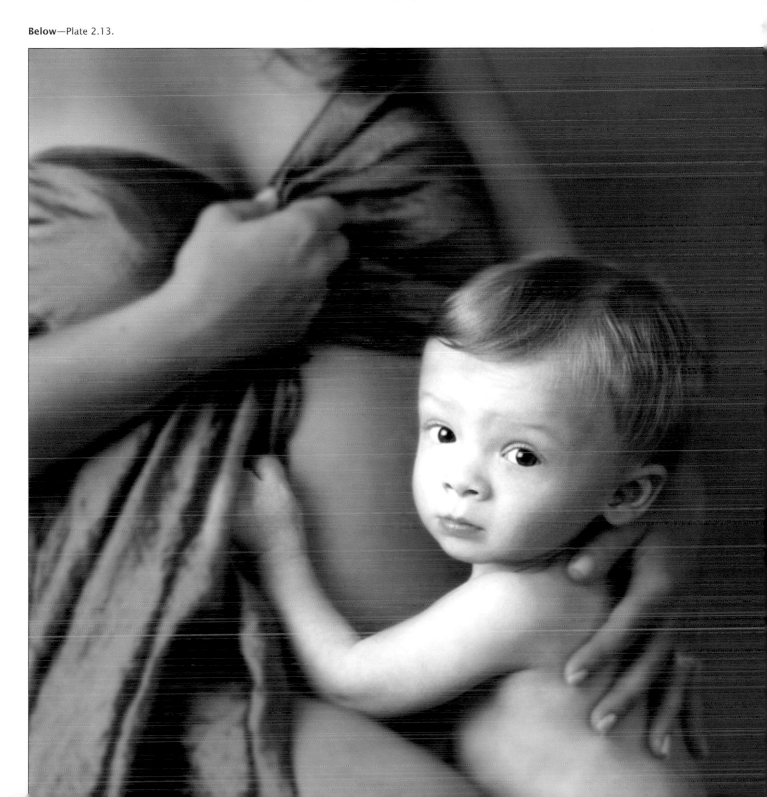

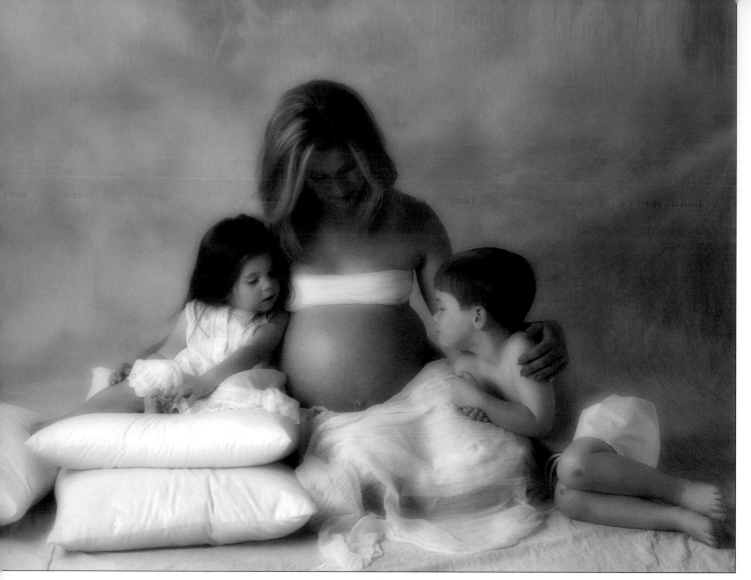

Above—Plate 2.14.

largely turned away from the camera, with his face turned back toward the lens. The main light was a large softbox to camera left. It originally illuminated the child and the mom's tummy, but Wendy finessed the image in Photoshop to subdue the mother's image and draw attention to the boy. It is an example of a way in which we are able to create different artistic variations in our images.

The composition is strong in the sense that the child appears in the right-hand third of the image so that we are drawn across the composition to the little person.

In plate 2.14, we have Sarah Johnston's portrait of a mom with her two children focusing on her preg-

nancy. It is a delightful example of simple lighting and posing technique. The main light was a large softbox at camera left, positioned so that the illumination skimmed across all three subjects. We can see its position by looking at where the shadow falls on the backdrop to our right. There is a differential of between $\frac{1}{2}$ to 1 f-stop. The falloff of the light to the right caused the mom's head and shoulders to fall into shadow, and this brought her tummy more into focus. This light ratio is 4:1, yet the boy at the right is illuminated with a ratio of less than 3:1. This also contrasts with the little girl, who is seen in a $3\frac{1}{2}$:1 ratio.

Sarah used two pillows to raise the little girl to her mom's shoulder level so the mother could easily em-

brace both children. The composition is triangular; it is an arrangement that is extrememly popular when photographing family groups.

Plate 2.15 (photo by Vicki Taufer) is a beautiful example of composition, lighting technique, and color harmony.

Vicki used a softbox at camera left and a little in front of the plane of the subjects. The light was slightly feathered so that it skimmed across the children's faces and struck the mother's tummy, rendering it in a 3½:1 ratio. A hair light was used at an exposure about 1 f-stop less than the main light. This created a nice highlight in the girls' hair, but the light was not so intense as to break down the modeling created by the main light. A fill light at approximately 1½ stops less than the exposure of the main light reduced what may have been a too-long ratio.

The angle at which each child's face is presented to the camera is different and appealing and adds a dynamic feel to the image. By tilting the camera to our left, Vicki was able to further intensify the contemporary feel in the image.

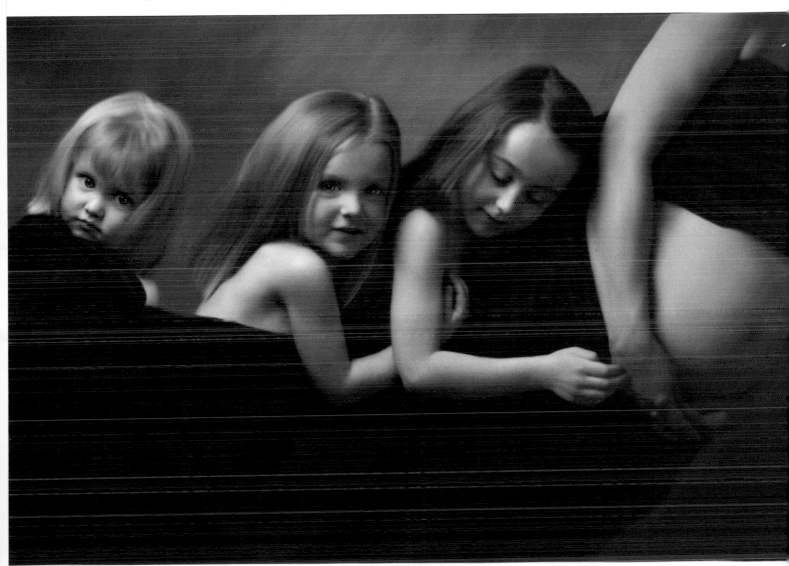

Above—Plate 2.15.

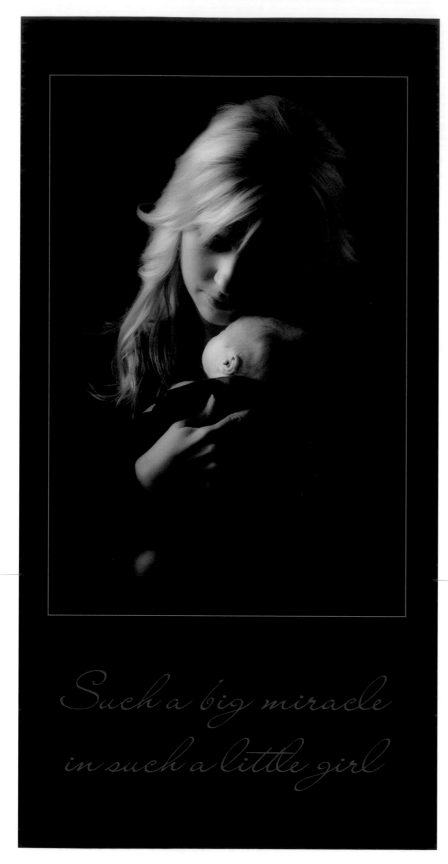

Such a big miracle in such a little girl

an excellent example of the steps that can be taken to increase the impact of your images.

The next sequence of images (plates 3.3–3.7; photos by Norman Phillips) illustrates how we can use window light in portraiture.

In plate 3.3, the mother and her baby are posed almost in the window frame so that the bright white wall creates a split lighting set and virtually blows out the highlights on her left cheek. The pose allowed the mom and her baby to respond to the camera.

In plate 3.4, the baby turned her head toward camera left. The change in position caused the light ratio on her face to be reduced. This is better for the baby, but it does not improve the lighting on the mother.

To create the image shown in plate 3.5, I moved the subjects away from the window to reduce the contrast and more evenly illuminate them. This eliminated the bright white wall near the window and made for a more acceptable set. There is a 2½:1 light ratio in the portrait.

In plate 3.6, the subjects were moved farther into the room, and the result was more even lighting. We now have a 2:1 ratio.

For plate 3.7, the subjects were moved once more. The mother was

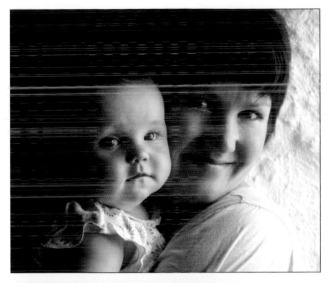

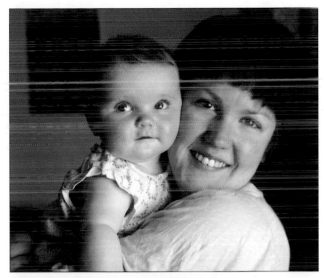

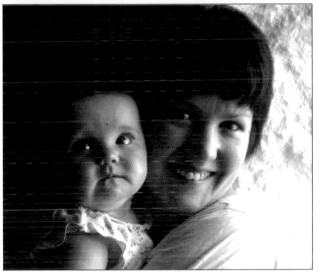

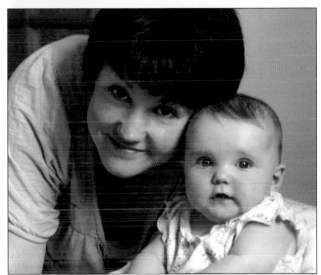

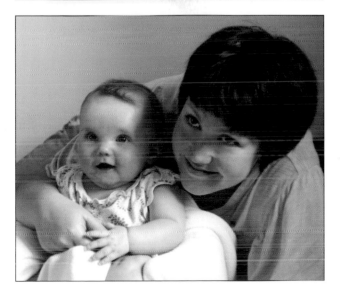

Top right—Plate 3.3. **Bottom right**—Plate 3.4. **Top left**—Plate 3.5. **Center left**—Plate 3.6. **Bottom left**—Plate 3.7.

positioned on the bright side of the set, and the subjects' angle to the light was more oblique. This caused the light to be feathered across the subjects. With the change in position and the mom's head partially blocking the light from falling on the baby's face, we achieved the desired 3:1 light ratio.

The posing in these portraits is conventional, with the mother and infant cheek to cheek but with the baby's head at a lower position in the composition, thereby creating a diagonal line between the subjects.

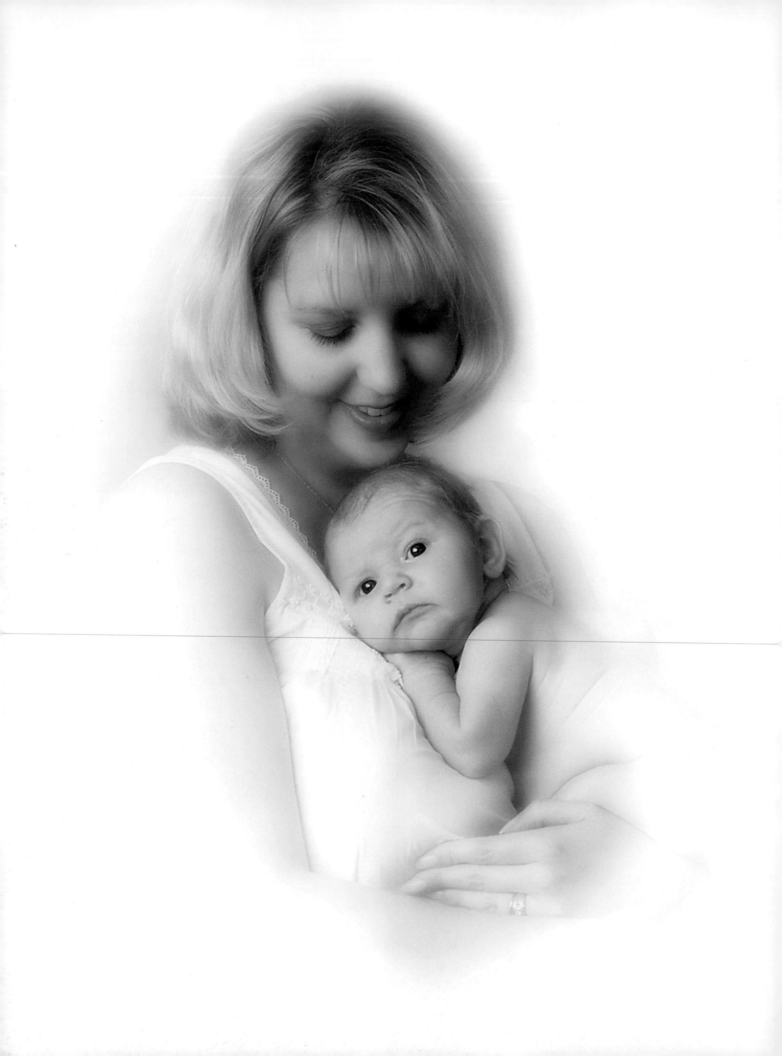

Plate 3.8 (photo by Wendy Veugeler) shows a baby resting against the mother and responding to the camera, creating a gentle, diagonal composition. The slight break in the diagonal line where the baby's head and mother's chin touch adds interest in the image.

There is a broad light pattern on the mother, creating a 3½:1 ratio that is very attractive. The baby is fully illuminated.

The main light was a large softbox at 45 degrees off both camera and subjects in a high-key set. A background light was used, and we can see that additional light was added from reflective surfaces in the camera room.

Wendy used Photoshop to great effect in this image. The vignette she created eliminates much of the periphery, leaving us to focus on the subjects' faces.

"Up close and personal" might well describe the image shown in plate 3.9 (photo by Cindy Romano). We get the impression that Cindy might have captured the image unnoticed while the mom was taking some time out with her baby.

The mood is beautifully serene. The portrait exudes calm and depicts a loving connection. The composition adds to the appeal; the angle of the divide between the two subjects created a modified diagonal composition.

Facing page—Plate 3.8. **Below**—Plate 3.9.

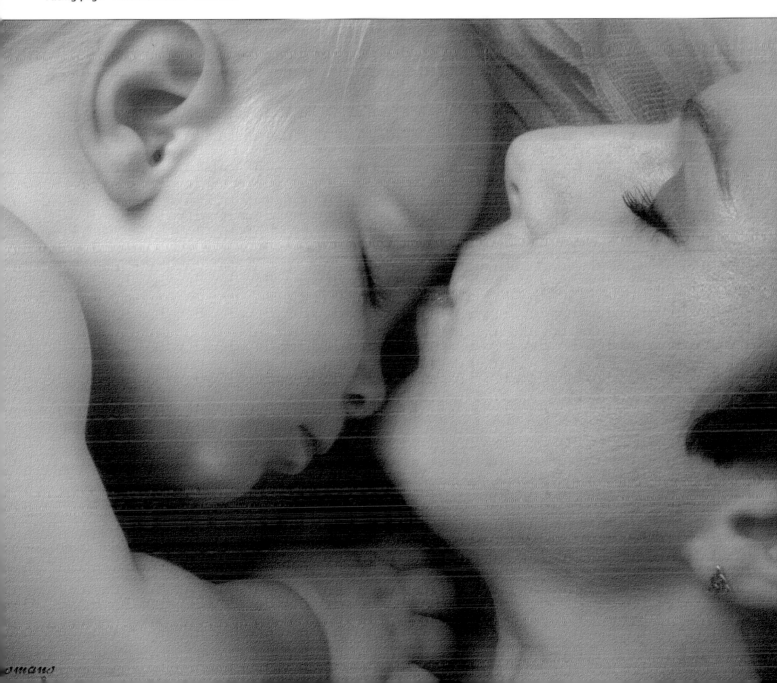

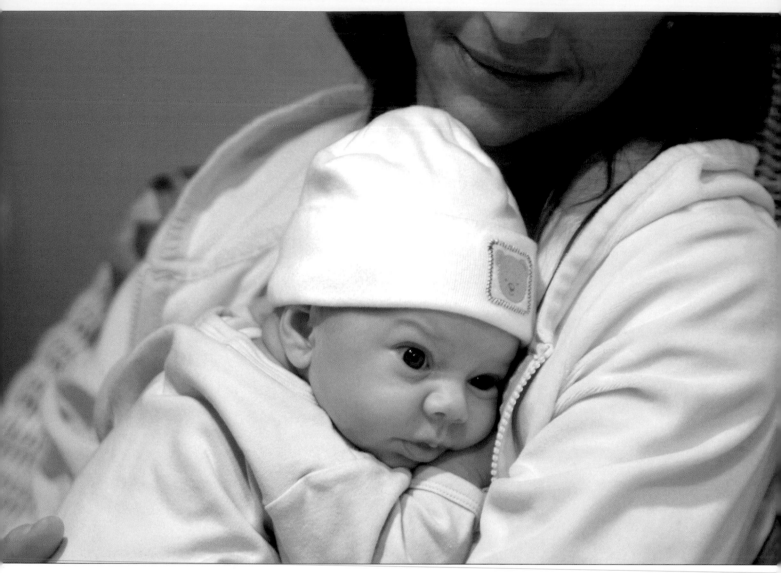

To light the image, Cindy placed a large softbox high to camera left, producing a modified broad lighting pattern.

Such an image works well when matted and presented in a 5x7- or 8x10-inch frame but may not make a good wall portrait, as the subjects' heads would appear larger than life size.

Plate 3.10 (photo by Terry Jo Tasche) is a relaxed composition with the mother seated in a wicker chair and her baby resting comfortably at her shoulder in a very gentle diagonal design. This is a natural pose for both the mother and baby and does not seem at all contrived.

The main light was a softbox positioned 45 degrees off subject and camera (at camera left), producing a $2\frac{1}{2}$:1 ratio.

Plates 3.11–3.13 (photos by Terry Jo Tasche) break new ground in portraits of mother and child. In none of these three images are we able to see the baby's face, but we can readily see the mom's love and excitement. Terry allowed the mother to vary her presentation to the camera and captured some delightful

expressions. Each perspective produced an image with a distinctly different feel.

Terry had mother facing the camera, so we are only able to see the back of baby's head.

The lighting is very unusual in this portrait. Terry used two lights, one on each side of the subjects and high on the background, illuminating both sides of the mom's face.

The lighting is accentuated in plate 3.13, where Terry adopted a much lower camera angle so that she was looking at the lights from behind the subjects. The placement of the lights resulted in the highlighting of the sides of the mother's face, with the mask of her face in relative shadow. The white fabric and a high-key set made use of a fill light unnecessary.

Top right—Plate 3.11. **Bottom left** Plate 3.12. **Bottom right**—Plate 3.13.

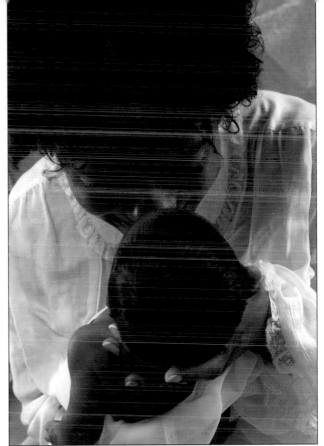

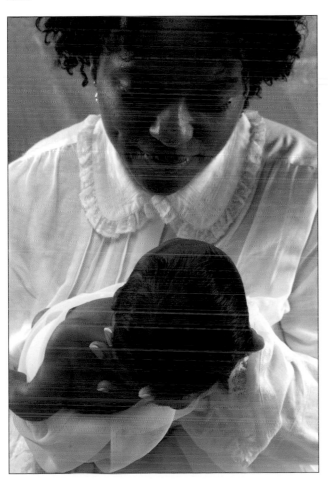

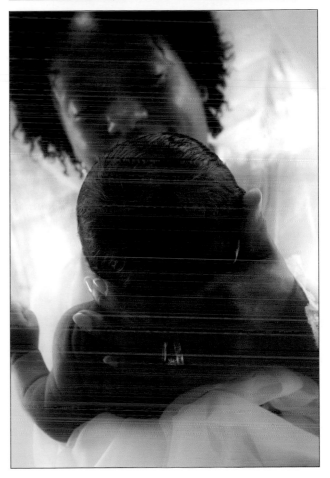

In plate 3.14, we see the mother posed in profile with the baby resting on her shoulder and facing the camera. Note how the baby's hand is under his face instead of passively resting elsewhere.

To light the image, Terry placed a softbox directly in front of the mother. The subjects were posed far enough away from the background to allow the light to illuminate the background. The image is in middle key.

Plate 3.15 (photo by Kerry Firstenleit) employs a different composition. The mother was posed on the floor and rested on her left elbow. Her baby, who was

Below—Plate 3.14.

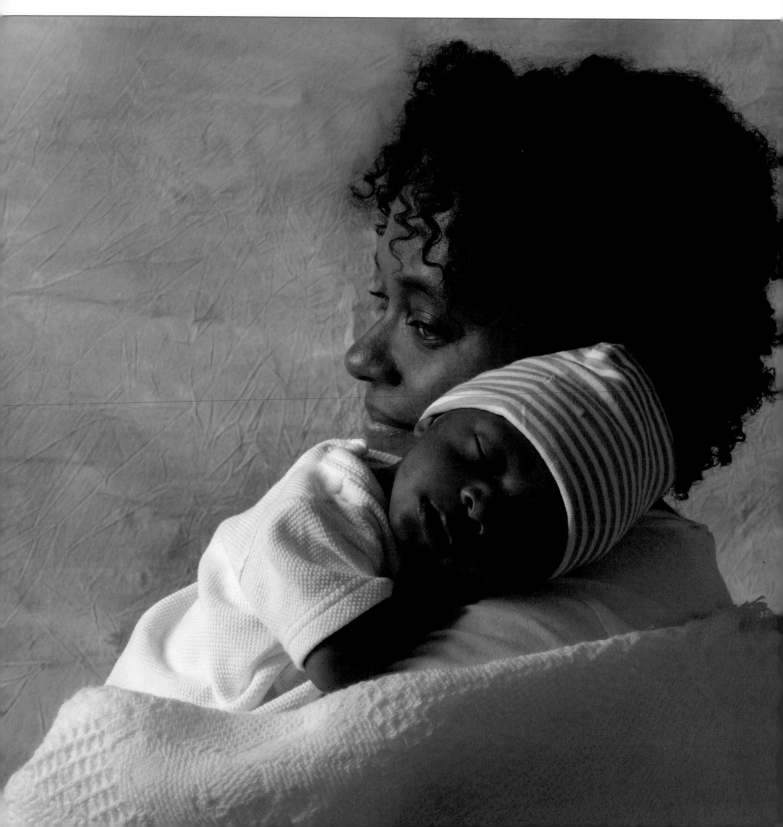

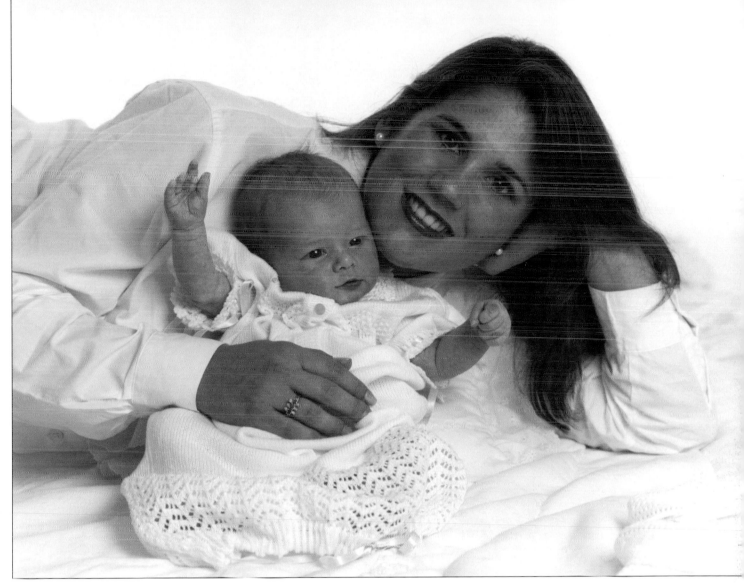

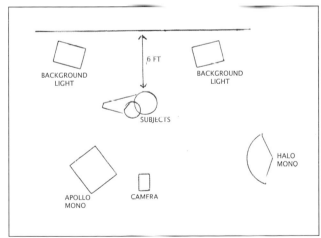

Top—Plate 3.15. **Bottom**—Diagram for plate 3.15.

clearly too young to sit without support, rested against her. The mom placed her right hand on the baby's tummy area to ensure she was safe and secure.

The posing is relaxed and casual—a style that is very popular with families. The mother presented an open face to the camera, but the baby was too young to respond to entreaties from the camera position.

A conventional high-key set was used, with the background illuminated at between ½ to 1 f-stop brighter than the light on the subjects. *(Note:* If you are still using film, you may need a wider differential, with up to 1½ to 2 f-stops more light on the background than on the subjects.)

The lighting setup included two lights on a track close to the ceiling that illuminated the background, a

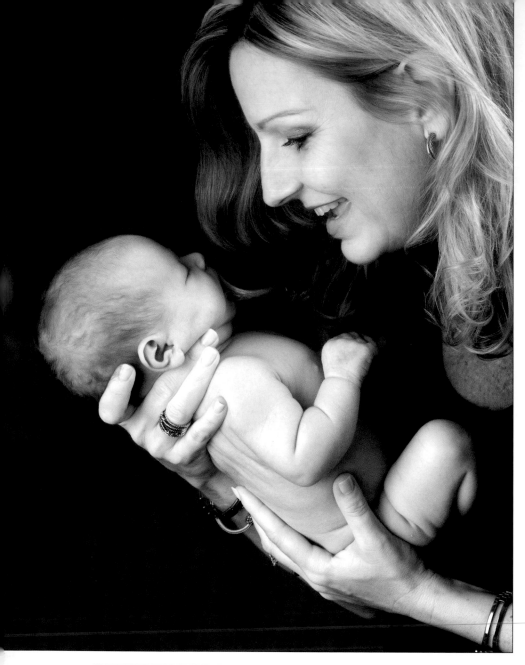

single-diffused Recessed Wescott Apollo Mono softbox at 40 degrees off camera as a main light, and a Westcott Halo Mono bounced off the right wall as a fill light. The angle of the main light, as it is closer to the camera, produced a ratio of a little less than 3:1. See the diagram for plate 3.15 (page 27).

Plate 3.16 (photo by Jeff and Kathleen Hawkins) shows a profile pose of the mother and her naked baby. When we present this pose, we demonstrate the relative size of the baby because the mother's hands are cradling her. Having the baby lifted close to the mom's head further emphasizes her small size.

A softbox was placed at 30 degrees off the subjects, with another softbox illuminating the back of the mother's head. This produced a relatively even lighting pattern with a ratio of a little over 2:1. By placing the subjects against a low-key backdrop, Jeff and Kathleen produced a dramatic contrast between the subjects and the background. The impact is strong yet soft and flatters both subjects. See the diagram for plate 3.16.

Plate 3.17 (photo by Terry Jo Tasche) is a happy and loving treasure. It exudes life and excitement, and the Photoshop enhancements used heightened the overall impact. Terry's Photoshop work downplayed the lighting, but we can see that a softbox was used high to camera right and slightly behind the subjects' position. This accented the highlights on both subjects. A second softbox at 45 degrees off camera left

created a pretty lighting pattern. A standard high-key background was used and converted to a tone that lent nice color harmony.

This portrait has a watercolor effect. Clients who are interested in a fine art image may find this presentation to their liking.

Mark Laurie is well known for his glamour style portraiture—a subgenre in which female subjects are typically less than fully clothed. In plate 3.18, the mom appears without any evidence of clothing. The image emphasizes the physical contact that is so crucial in the nurturing of an infant. The portrait is

Top—Plate 3.17. **Bottom**—Plate 3.18.

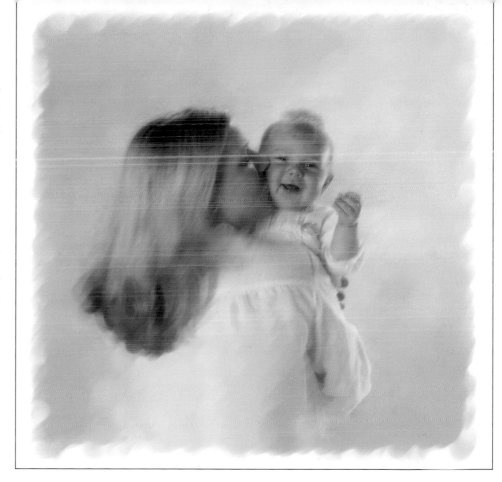

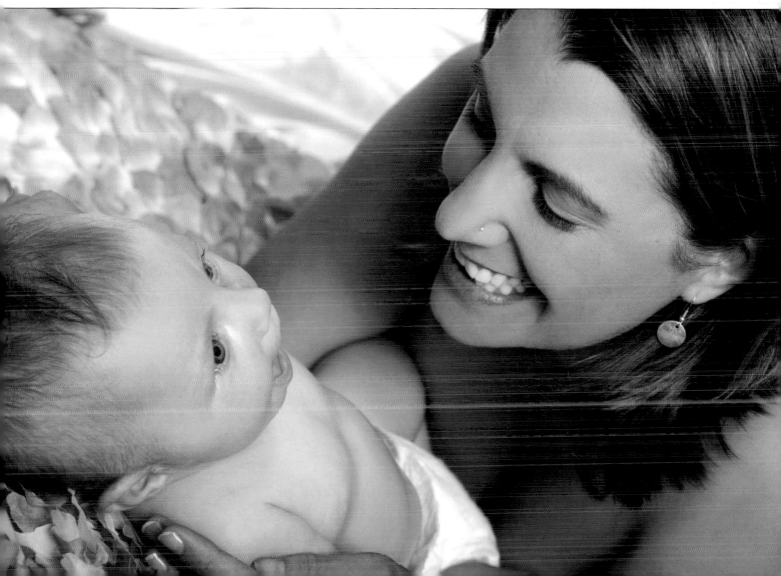

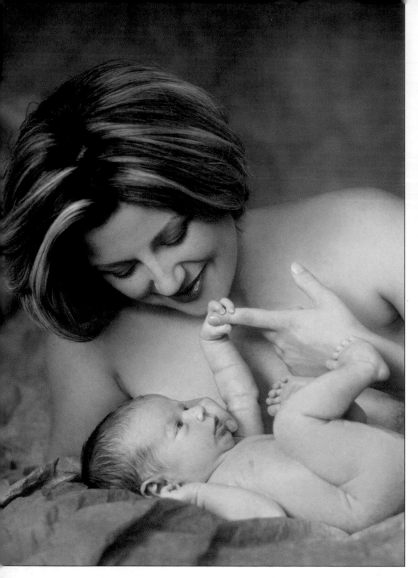

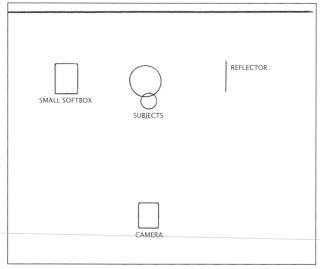

Left—Plate 3.19. **Top right**—Plate 3.20. **Bottom right**—Diagram for plate 3.20.

simply delightful. It shows the happiness that the two share, even if the baby is unable to express it at such an early age. It is the impression that we should seek to create when photographing a mom and her infant.

Mark used a large 40x60-inch softbox at 45 degrees from the camera and subjects (at camera right) in a brightly lit set, where the ambient light provided fill. The overall lighting produced a beautiful rendering of the subjects' skin tones.

Plate 3.19 is another Mark Laurie portrait that depicts the natural, nurturing bond between a mother and her baby. It is beautifully feminine and evokes the tenderness associated with motherhood.

A 40x60-inch softbox was placed at camera right, and a large reflector at the left of the subjects provided a fill source equal to ½ f-stop less than the main light. The overall lighting cast an even illumination across both figures and beautifully rendered the skin tones.

The pose shown here is natural and needed only a little refinement from Mark to ensure the subjects' best-possible presentation to the camera.

In plate 3.20 we see an image from Jody Coss. The high-contrast, black & white portrait created against a black backdrop shows a very contemporary approach.

The portrait was lit with just one light—a small, diffused softbox at 40 degrees from the subjects at camera left. The diffused light enabled Jody to capture detail in the black clothing and beautifully sculpted both figures. A reflector placed off to camera right softened the deep tones on the baby's right shoulder. See the diagram for plate 3.20 (page 30).

The pose beautifully illustrates the connection between the mother and her baby. The mom is addressing the camera with a quiet and sincere expression, which helps make this a very appealing portrait.

Jody added a digital mat to the image in Photoshop. This form of presentation eliminates the need for cutting a mat before framing and is another example of how we might present our images.

Plate 3.21 is another portrait by Jody Coss. Jody once again employed a low-key background. This time, she used a main light, hair light, and fill light—a more conventional setup. The main light was a medium softbox placed to camera right and almost on the same plane as the subjects, with the bottom edge of the box level with the baby's head so that it modeled both subjects. A second softbox placed behind the camera at 1½ stops less than the main light gently filled in the shadow areas that are facing the camera. A third softbox was positioned behind and to the left of the subjects. It added highlights on the mom's

hair. This lighting setup produced a 3:1 ratio with delightful highlights on both the mother and child. A 3:1 ratio does not typically create the depth seen in this portrait. Here, the modeling of the mom's features is exemplary, and the light on the baby produced the right balance of shadow and delicate highlight. See the diagram for plate 3.21.

The posing created two interesting delicate diagonals, one that begins at the mother's head and runs to the baby's head, and another that runs from the baby's head and down through the mom's right arm.

Plate 3.22 shows another Jody Coss portrait, also photographed against a low-key background and with

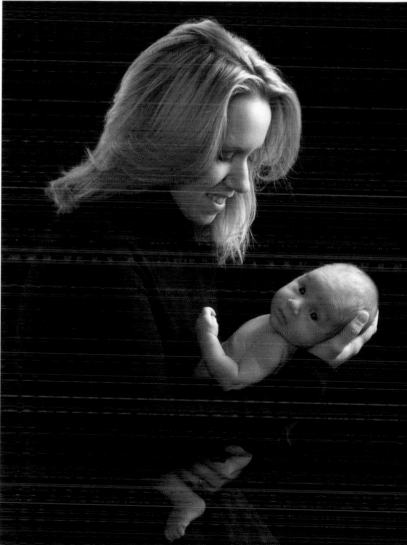

Right—Plate 3.21. **Below**—Diagram for plate 3.21.

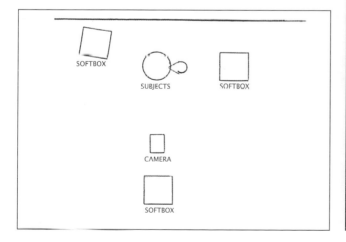

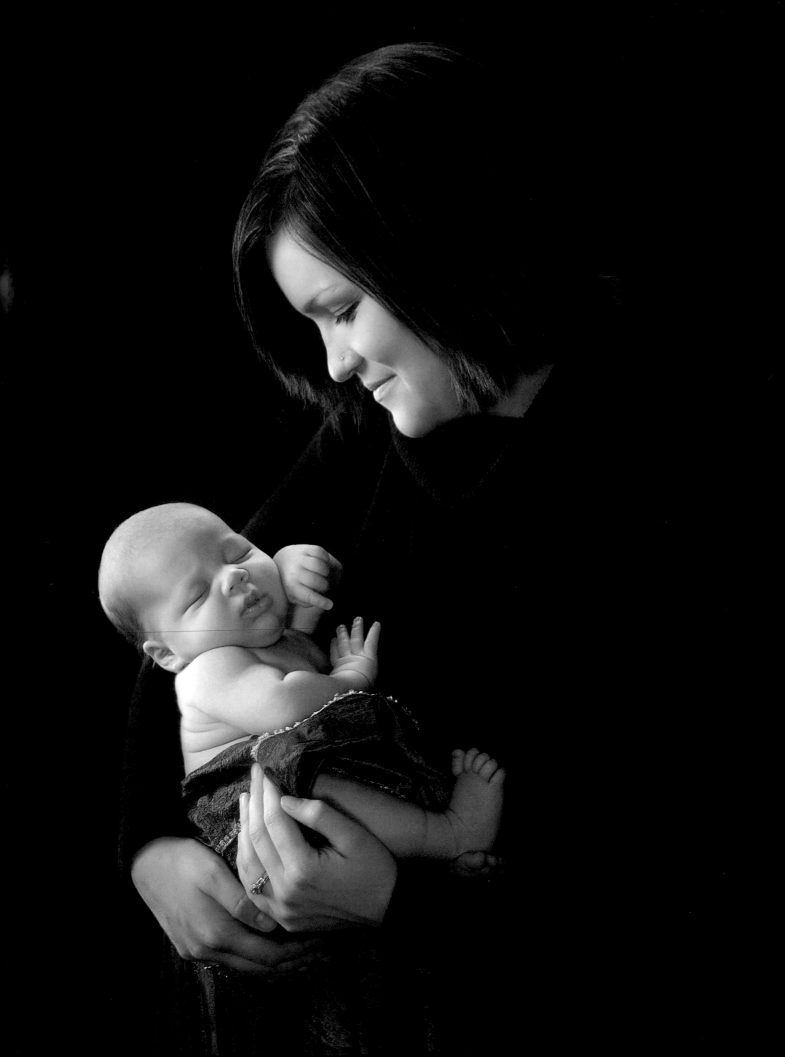

beautiful modeling of the subjects. Jody achieved a gentle 2:1 ratio with a single-diffused softbox positioned slightly behind the plane of the subjects. The light perfectly illuminated the mom's profile and created separation between her hair and the background. A second softbox was placed behind the camera. It provided ½ of an f-stop less light than the main light, allowing for the rendering of detail in the mother's hair, on her hand, and on the baby. The light did not compromise the modeling of the subjects.

There is also nice texture in the dark clothing, but due to the diffused lighting, the contrast is reduced. Harsher lighting would have created higher contrast, and there would be no detail.

The pose provides us with a lovely profile of the mother and a perfect view of the child.

In plate 3.23 (photo by Norman Phillips), the mom is shown partially clothed and cradling her baby close to her body and diagonally to the camera. Both the mother and baby are in profile, and the length of the

Facing page—Plate 3.22. **Below**—Plate 3.23.

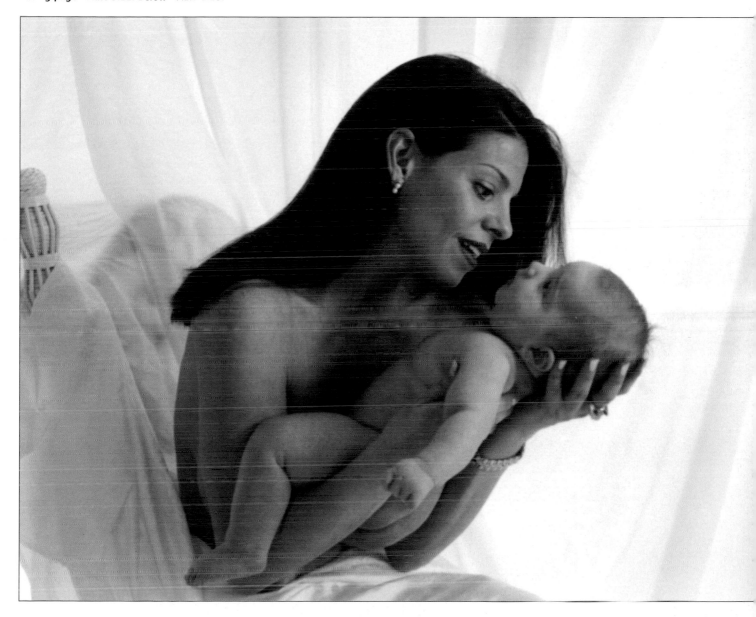

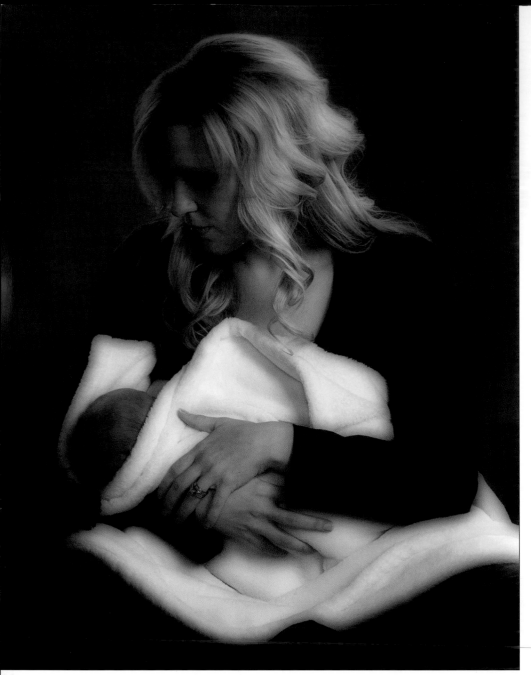

infant's body adds an effective diagonal line in the composition. At this age, a baby must be quite close to the mother to make eye contact.

To ensure that we had a full view of the length of the baby's body, his left leg was placed over his mother's right arm, which accented the diagonal.

A conventional high-key lighting setup was used: there were two track lights on the background, a 28x42-inch Westcott Recessed Apollo Mono as the main light at 50 degrees off camera right and an umbrella fill light, set to one stop less than the main light, positioned behind the camera. The delicate fabrics behind the subjects softened the impression.

Plate 3.24 (photo by Jody Coss) breaks most of the rules in lighting portraiture, but with its strong contrast it has appeal and impact. The main light was a softbox placed at camera right and at 45 degrees off both camera and subjects. A hair light illuminated the mom's hair and shoulders, and a fill light from behind the camera at half of the power of the main light balanced the overall composition. Jody turned the mom away from the main light to create the lovely and dramatic lighting effect. See the diagram for plate 3.24.

The posing is perfect. Normally I would avoid showing the backs of the hands, but the hands are beautifully arranged here. Hands are always a challenge, and only those with a special skill achieve flattering hand poses.

HAIR LIGHT

SUBJECTS

SOFTBOX MAIN LIGHT

CAMERA

SOFTBOX FILL LIGHT

Another interesting aspect of this image is that the mother is feeding the infant. The placement of the white blanket ensures modesty, and a reflective, gentle mood is depicted in the image.

Plate 3.25 (photo by Norman Phillips) was created in a high-key set with the main light to the right of the camera. The concept was simple: I wanted to have the mother cheek to cheek with her baby. This was achieved by having the mom place her elbows on a waist-high riser so that when she moved her head close to her baby, she would not put too much weight on him. The mom's left hand isn't in the most flattering pose, but it escapes serious criticism, as she is delicately holding her baby's hand.

The window set was positioned 4 feet from the white, high-key sweep, and the subjects were positioned 18 inches from the window set to ensure they were in the correct zone of the high-key set.

The image in plate 3.26 (photo by Sarah Johnston) breaks with convention in that it provides only a back

Below—Plate 3.25.

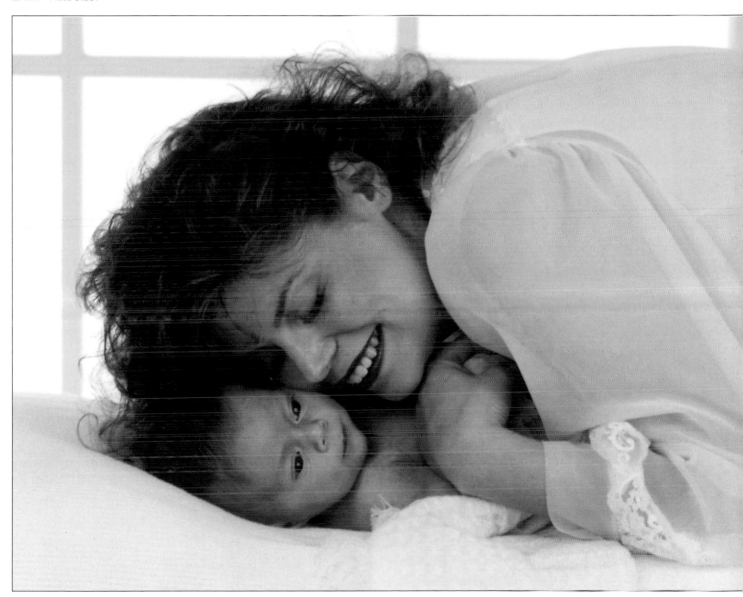

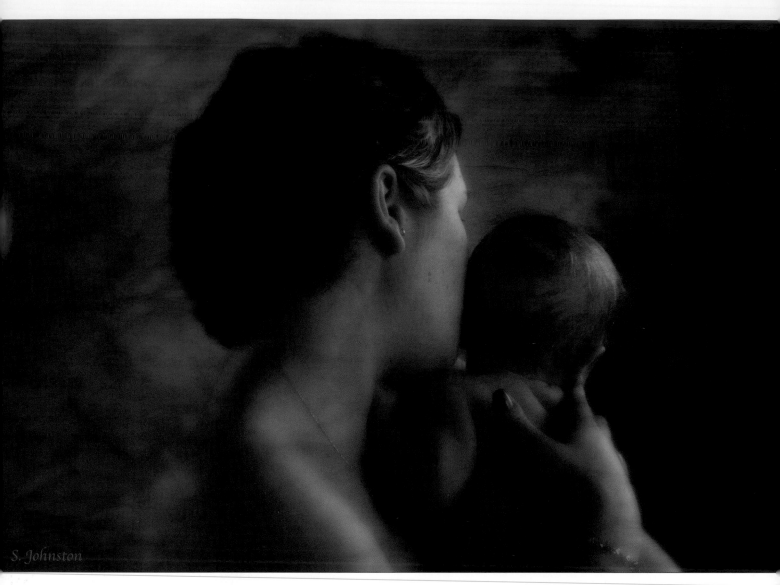

S. Johnston

BACKGROUND

STRIP LIGHT
WITH
EGG CRATE
(ACCENT
LIGHT)

4x6 SOFTBOX
(MAIN LIGHT)

SUBJECTS

SILVER REFLECTOR

4x6 SOFTBOX
(FILL LIGHT)

CAMERA

Top—Plate 3.26. **Bottom**—Diagram 3.7.

view of the mother and baby. We will see images that provide only a rear view of baby, but mother will generally be presented to the camera. So how do we respond to such an image?

This image breaks even more into the fine art concept than the image shown in plate 3.24. It provides a view that we may not normally consider, but given a few moments to absorb the concept of the portrait, we see a striking rendition of both the mom and baby. The baby is portrayed beautifully, showing how those tiny arms are dependent on the support of mother and also the protectiveness of the mother's hand.

Two large softboxes were placed to the subjects' right. One was positioned close to the background; this served as the main light. The second softbox was placed to camera right and between the subjects and camera on the same side of the set; it served as the fill light. A third light, a smaller softbox, was positioned between the subjects and background well to the left of the camera and angled toward the mother and baby. A reflector was positioned at 45 degrees off both subjects and camera, to camera left. See the diagram for plate 3.26 (page 36).

Plate 3.27 (photo by Jeff and Kathleen Hawkins) is a variation on several previous images and uses an interesting lighting pattern on the mother's face. Conventionally the deep shadow from the mother's nose would be frowned upon, but expression sometimes trumps perfect highlight and shadow, and in this instance, this is the case. This does not suggest that the portrait is unacceptable in terms of lighting technique; in fact, the mother looks beautiful, and there is still a little catchlight in her left eye. This catchlight is important, and when we are creating these portraits, it is a must. If the catchlight isn't captured in the camera for whatever reason, it should be added in post-capture.

The position of the baby in this image is interesting and a little different from that shown in the images reviewed thus far: she has been elevated to the level of the mother's forehead. The mom is tilted to our left (probably due to the camera angle), resulting in a very nice diagonal composition.

A medium softbox was placed high to the left of the camera and 40 degrees off the subjects, an angle that created a 4:1 ratio, as the mother has slightly turned her head toward her baby and turned her shoulders slightly in the same direction. The height of the main light has eliminated the need for a hair light. A back-

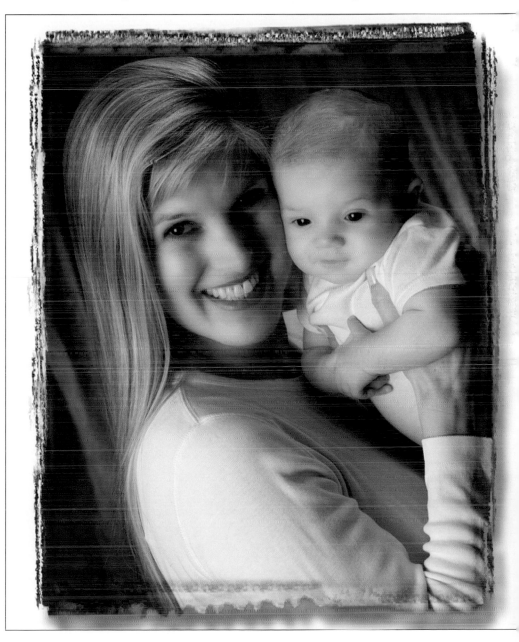

Right—Plate 3.27.

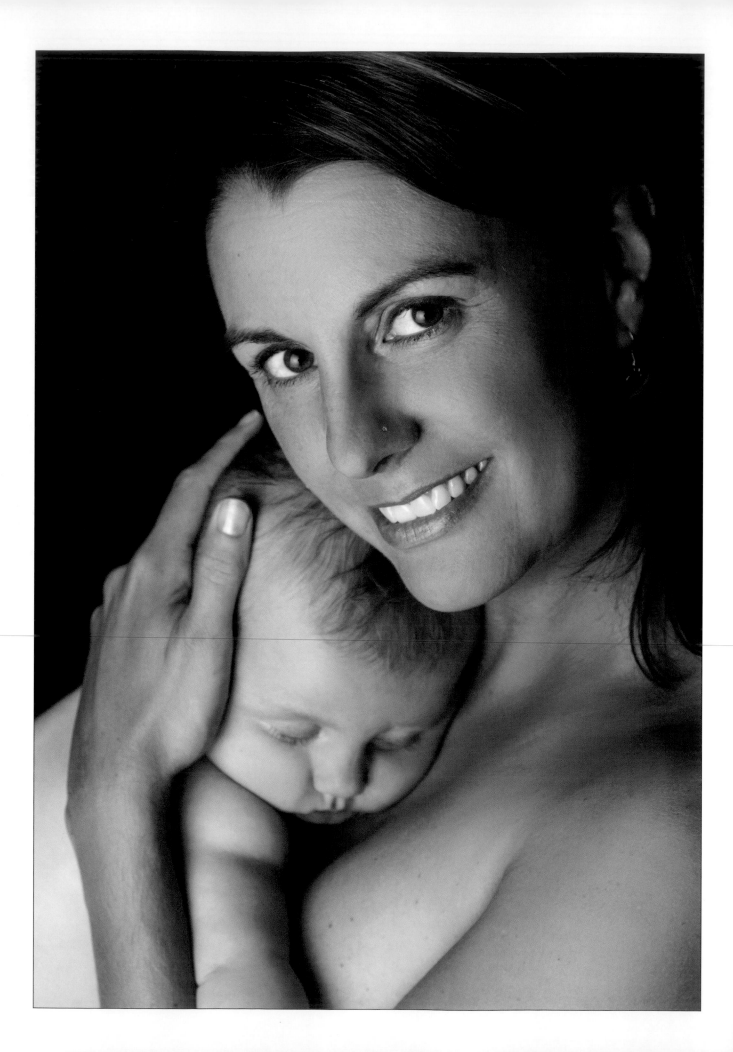

ground light was used to seperate the subjects from the background.

Plate 3.28 is another Mark Laurie portrait that has lots of beautiful skin tones. The mom and baby were lit with a single 4x6-foot softbox placed 50 degrees from camera left. The angle of the light produced a 4:1 ratio, but this is not too harsh, as it only applies to the mother's left cheek, while nicely illuminating the baby. The difference between this portrait and others that have the baby at the mom's shoulder is that the baby is on the far side of the image. This has allowed the mother's face to break the plane of the baby's head, producing a different perspective. Also the mother's hand is protectively at the side of the baby's head. It is a variation of the cradling of a baby.

This portrait is an example of a single-light illumination. The large softbox provides a softer light source than a smaller one. Also, the larger the light in relation to the subject, the softer the light. A soft light wraps around the subject in a way that harsher light does not. Ultrasoft light wraps around to an even greater degree, but many see this light as flat, as the modeling is much less pronounced.

To create the image shown in plate 3.29, Mark Laurie employed a 4x6-foot softbox at 45 degrees off camera and subjects. The modeling is gentle with no harsh shadows, and we have a 2:1 ratio. The light caresses the mother and baby, rendering beautiful skin tones. When placing the softbox at the 45 degree position, and sometimes even more obliquely, you may be able to avoid using a fill light (the use of a large reflector on the opposite side may be desirable, however). In this image, Mark did not use a fill source, so the ratio at the mother's back is a little over 3:1.

Mark posed the mom in profile with the baby nestled against her chest, then had the baby face the camera while the mom turned slightly toward the camera.

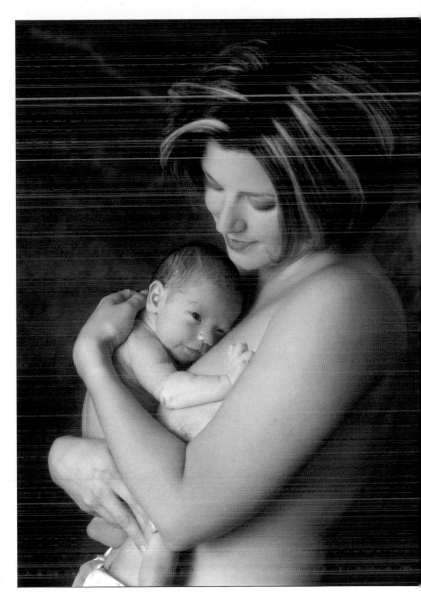

This caused her to look toward the baby at an oblique angle, and we see a very pretty impression of her features. The subjects' positions caused the mom to tip her head, which is key to the success of the portrait.

The Jody Coss portrait shown in plate 3.30 (page 40) is yet another created in a low-key set with the use of a medium softbox as the main light. This light was positioned at a 45 degree angle to the right of camera. Had a more oblique position been used, a fill light would have been required. A second light was positioned to the left of the camera and behind the subjects at ½ of the power of the main light. This

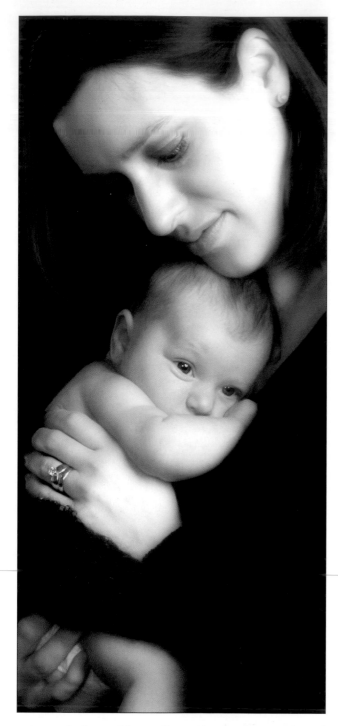

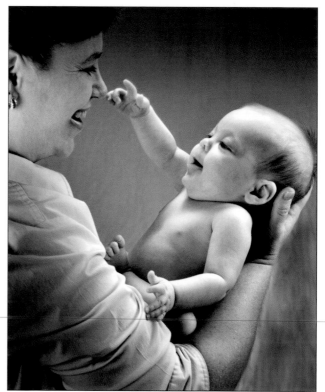

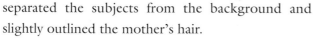

Left—Plate 3.30. **Top right**—Diagram for plate 3.30. **Bottom right**—Plate 3.31.

separated the subjects from the background and slightly outlined the mother's hair.

The positioning of the baby is a modification of the one shown in the previous portrait. The baby is higher on the mother's chest and closer to her left shoulder, and this time the mother's chin breaks the outline of

the baby's head so that there is a direct connection between the two.

The posing produced a stronger curved pattern and a more dynamic feel, as the mother's head is tilted to our left and the baby is positioned at a gentle diagonal to our right. Conventionally, we would seek to hide the mother's right eye or seek to illuminate it—

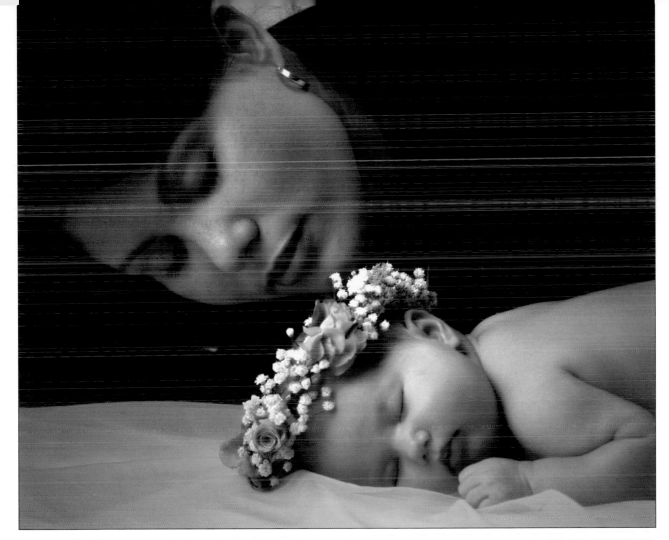

Above—Plate 3.32.

and a slight turn of the mom's head toward camera left would have hidden the eye—but the portrait has great impact. See the diagram for plate 3.30 (page 40).

Plate 3.31 (photo by Jeff and Kathleen Hawkins) shows a baby who is a little older and is able to interact with the mother. When we are working with an infant of this age, the mother should support the baby's head with her hand or it will fall backward. In this position, the baby has eye contact with the mother, which enables the interaction we see here.

The baby, who was supported by the mom as she was held at a 40 degree angle, was positioned with her feet and legs on her mom's tummy.

Two lights were used to create an unusual lighting pattern that is focused on the baby. One was positioned to the right of the camera and almost on the same plane as the baby, and the second light was positioned behind the mom and directed over her shoulder to illuminate the baby. Barn doors were used on each unit to prevent the light from focusing on the mother. The mom was illuminated using only ambient light from the set. As a result, she is rendered in subdued tones and the baby is the focus of the image.

Plate 3.32, also by Jeff and Kathleen, offers a different perspective of a mother and child with both facing the camera but not interacting with it. The baby is in a typical sleeping pose, and the mother is positioned behind her. The dark shirt that the mother is wearing helps to focus the viewer's attention on the baby, who appears in strong relief against the dark tones.

The main light, a medium, double-diffused softbox, was positioned above and just in front of the camera.

The light was directed primarily onto the baby, but because the softbox was double diffused, the edge of the light also illuminated the mother. We are able to see the double diffusion because the skin tones of both subjects are very soft, there are clean whites in the baby's headpiece, and the white sheet on which the baby is lying is not a clean white.

Jeff and Kathleen did not use a hair light, so there is no visible detail in the mother's hair. Had a hair light been used, it would have produced a shadow below the mother's hairline, and that shadow area would have needed to be filled in. To have used such a light would have compromised the lighting on the baby.

Plate 3.33 (photo by Norman Phillips) shows an interaction between an enthusiatic infant and his mom. The pride and joy that his mother exudes makes the image shine.

This image was taken from an interesting angle, with the mother tilted. Both subjects were posed in profile. The concept is simple, and the pose is representative of many of the moments the two share.

Below—Plate 3.33. **Right**—Diagram for plate 3.33.

A makeshift basinette was created using a bench and white bedding. The mother was positioned on the far side of her son in a kneeling pose with one elbow on either side of her child. At almost five months old, the baby was old enough to interact with his mom, and the two were enjoying each other. The resulting expressions are charming.

A single-diffused, 28x42-inch Westcott Recessed Apollo Mono was the main light, positioned 50 degrees off camera left. A 2½:1 ratio was attained by employing two other lights—a Westcott single-diffused, 12x36-inch Stripbank positioned above and slightly

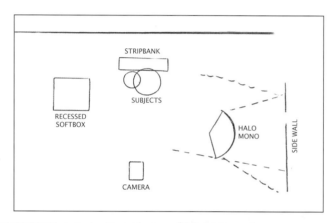

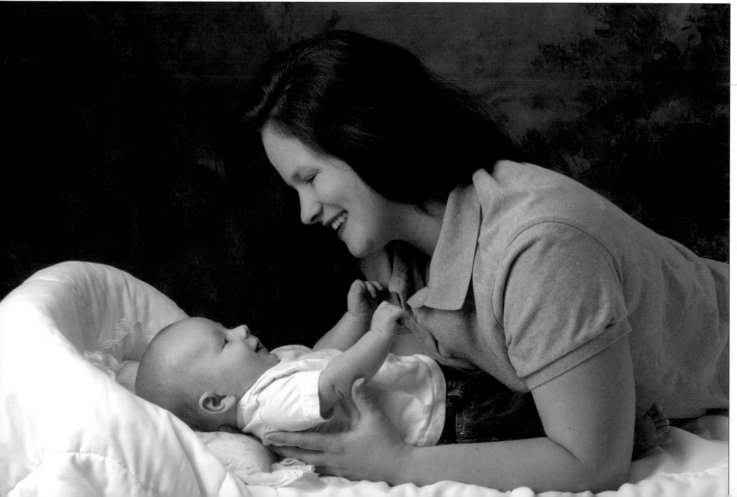

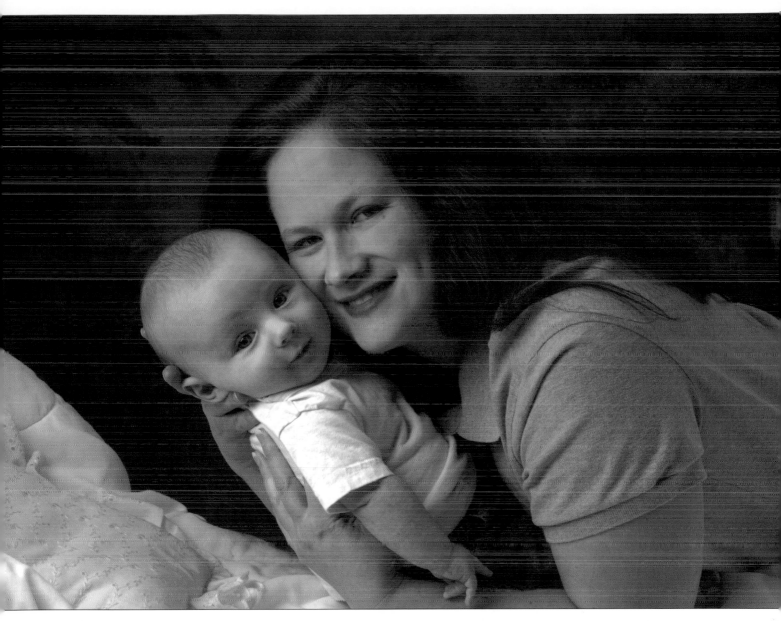

Above—Plate 3.34.

behind the subjects, which served as a hair light, and a Westcott Halo Mono bounced off the wall at our right to provide fill. The main light was powered at f/11, the hair light at f/5.6, and the fill light at f/5.6. See the diagram for plate 3.33 (page 42).

In plate 3.34 (photo by Norman Phillips), the subjects were in the same position, but the mother placed both hands behind her baby, raised him up to her cheek, and turned toward the camera, creating two different impressions, one lighting and the other compositional.

With the mom turned toward the camera, a 3:1 ratio was attained, as the main light skimmed across the subjects' faces. The composition changed as well: we now have a strong diagonal that runs from the top left of the frame to the bottom right. Though the change in position was small, the lighting changed dramatically.

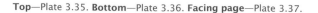

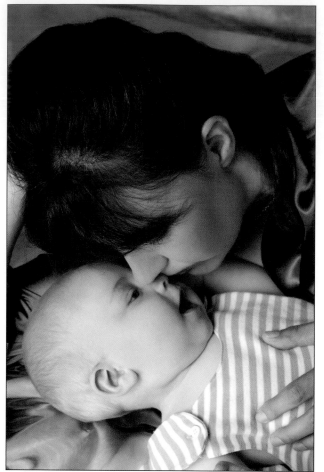

Mark Laurie shot the portrait in plate 3.35 from an unusual angle. Mark had his camera positioned for another shot, but when the mom dropped her head to meet her baby's, he saw the opportunity to capture a beautiful moment between the two. The pose resulted in two different light ratios on the subjects—the lighting on the baby is flat, or a 1:1 ratio, and the light on the mother is 3:1.

In plate 3.36, Mark again followed his bent for using unusual angles to document the interactions between his subjects. By handholding the camera, Mark was able to move over his subjects to document the baby's reaction to his mother's playful actions. The resulting image showcases the baby's sheer joy.

___The original set had the subjects profile to the camera, and by using a large softbox, which provides a wide and soft wraparound light, Mark achieved a 2½:1 ratio. A smaller softbox would have produced a more focused light and sharper modeling, which is not Mark's style.

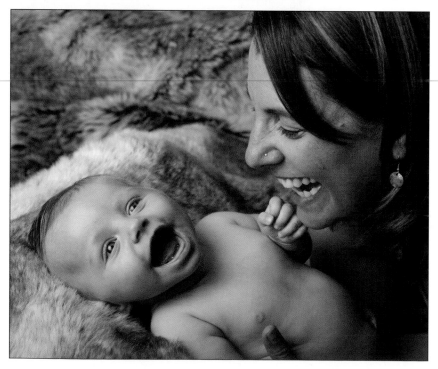

The lighting pattern shown in plate 3.37 (photo by Sarah Johnston) is the result of not only the position of the lights, but the way that the fabrics used in the set controlled the light. Beginning with the lighting set she used to create the image shown on page 14 (plate 2.11), Sarah had the mom drop down to her baby, who had sunken into the pillows and fabrics. The fabric and the mom's pose narrowed the focus of the light as barn doors would. The baby was rendered in a 3½:1 ratio, with the mom in the shadow zone of the same ratio.

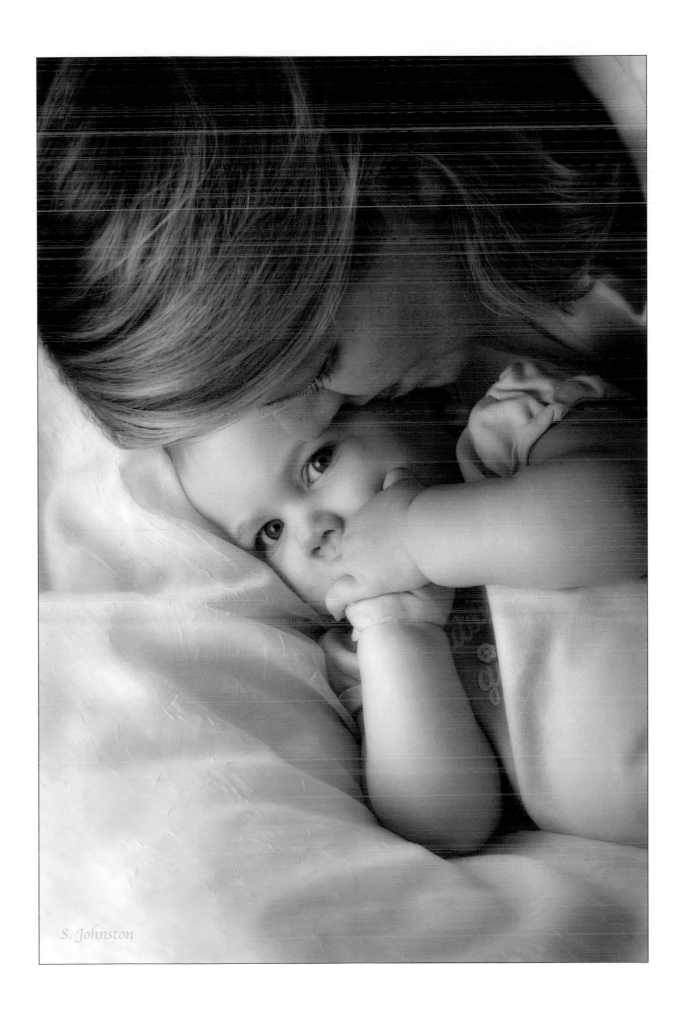

S. Johnston

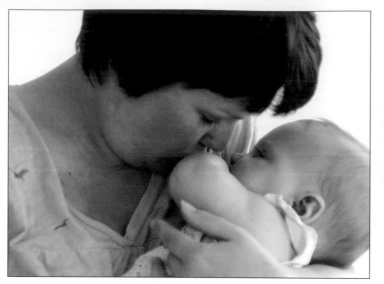

Plate 3.38.

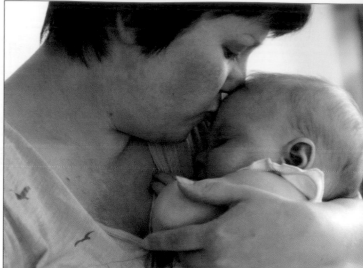

Plate 3.39.

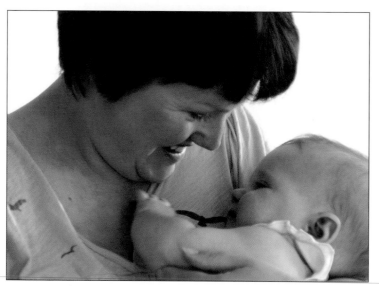

Plate 3.40.

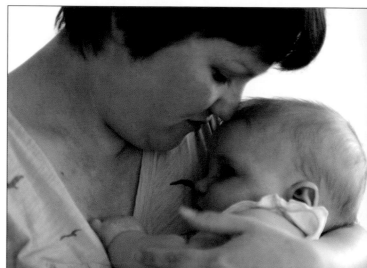

Plate 3.41.

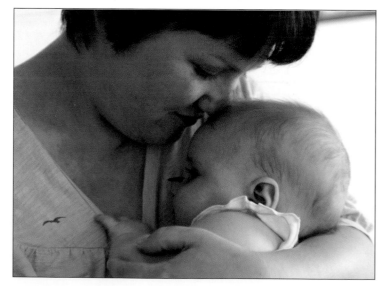

Plate 3.42.

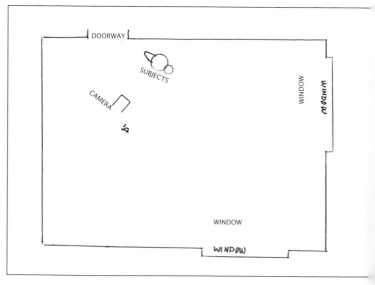

Diagram for plates 3.38–3.42.

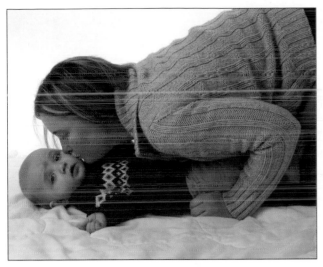

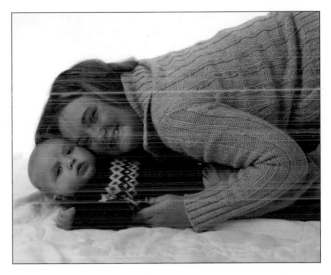

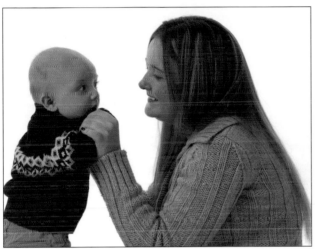

Top left—Plate 3.43. **Top right**—Plate 3.44. Bottom—Plate 3.45.

The images shown in plates 3.38–3.42 (photos by Norman Phillips) were shot at the subjects' home. I wanted a set that was as close to high key as I could find, and the family's kitchen was the ideal location. There were two windows that provided the light, one behind my camera and one at my right. The white walls made the light coming from the average-sized windows more than adequate for high key. The light was fairly even across the room, so the lighting on my subjects is even with just a hint of a main light effect, mostly because of the angle of the subjects relative to the windows. See the diagram on the facing page.

The baby is almost five months old in these images. The session was held at a time of day when she had just been fed and was somewhat sleepy. I wanted to produce a sequence of images that depicted the mother's love for her baby. My camera position did not change more than a few inches as I photographed the mom showing her affection for her baby.

Sometimes we have a young subject who is very aware that the photographer is active, and he or she will show more interest in us than in interacting with the mother. We see this in plate 3.43. The image is one of three shown here as we sought a way to have the little person interact with his mother. In this first image we had the baby on his back and the mother on her knees so that she could bend over him. The original idea was to have him respond to his mother's entreaties, but the camera was more attractive to him, so we modified the pose by having the mother cheek to cheek with him so that both are looking at the camera as shown in plate 3.44. Aside from a change in the mom's pose, everything remained the same.

To entice Junior to interact with his mom, I had him stand with her support as seen in plate 3.45. Most babies this age are eager to stand on their own, and we took advantage of that fact here.

A conventional high-key setup was used to create the image. The main light was positioned to camera left and produced a 3:1 ratio.

In plate 3.46 (photo by Joanne Alice), we see a variation of a baby-over-the-shoulder portrait. Joanne had the mother slightly turned away from the camera with the baby at the edge of her shoulder so that the infant was slightly in front of her. Because the main light came from the right of the camera, the baby's head blocked part of the mother's face, causing a relatively long ratio on the woman's face. This lighting pattern created an attractive separation between the mother and the infant. The light is focused on the baby, and the mother is lit as the supporting element in the composition. The highlights on the baby's left side appear blown out, but the infant's beautiful eyes steal the show and focus the viewer's attention right where it belongs.

There are two separate lighting patterns in the image, each with a separate light ratio. The baby is presented in a 3:1 ratio despite the blown-out highlights. The mother is in a 4:1 ratio, which is acceptable because she is the supporting element in the image and is key to the composition.

Joanne used a fill light to shorten the ratio in the front of the image. The baby is also partially lit by the reflected light from the mother's white top.

Note too the way the mat Joanne created in Photoshop enhances the presentation.

Jody Coss created the portrait in plate 3.47. The portrait shows an interesting perspective, since the angle of the mother's body to the camera makes her body appear wider than it would with a more standard presentation. The beautiful lighting and rendering of the skin tones—plus the diagonal line that runs through the composition—is very pretty.

Jody positioned a large softbox at the mom's head height and to camera right, producing an exposure that is commonly seen in glamour photography. A second large softbox was placed to camera left and a little behind the plane of the subjects. This rim lighted the mom's arm and rendered her right shoulder similar to her left. An accent light was used to create separation from the background.

The mom's angle to the camera shielded the baby from the second light. As a result, the baby is rendered in an almost 3:1 ratio, while the light ratio on the mom is 2:1.

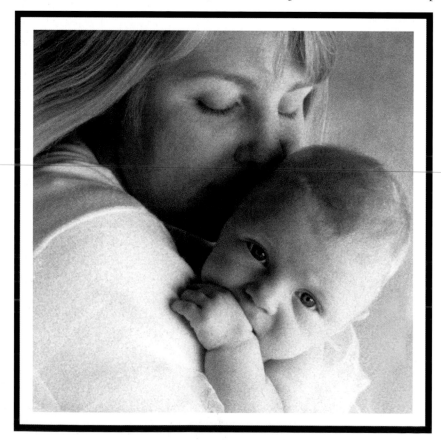

Left—Plate 3.46. **Facing page**—Plate 3.47.

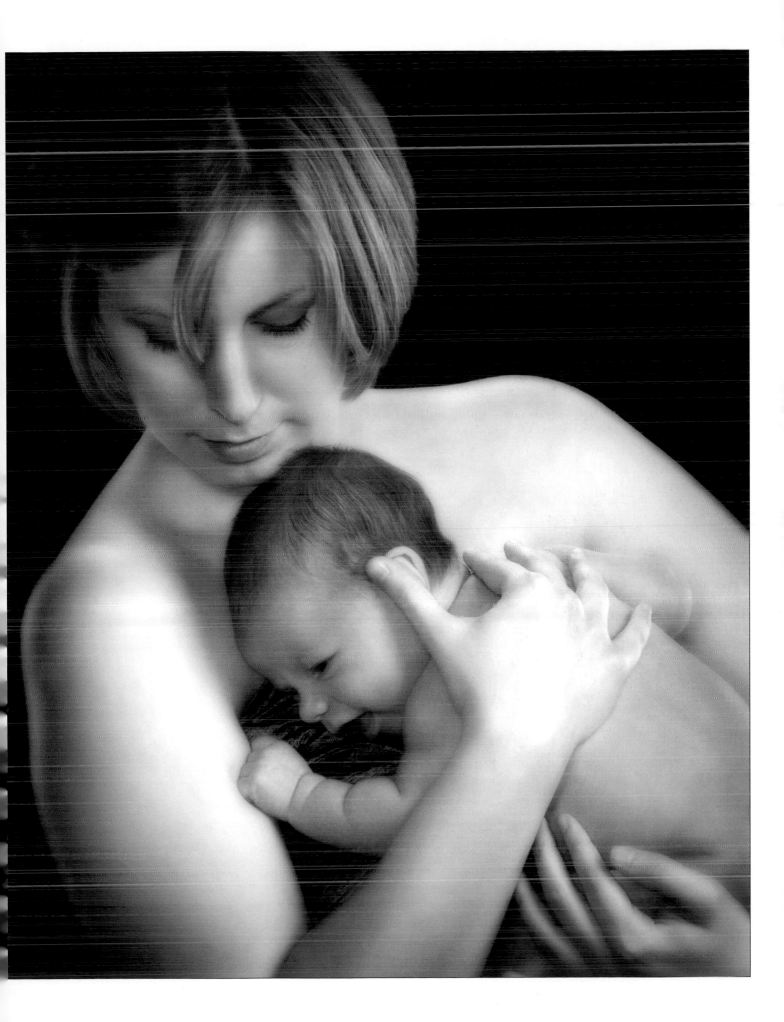

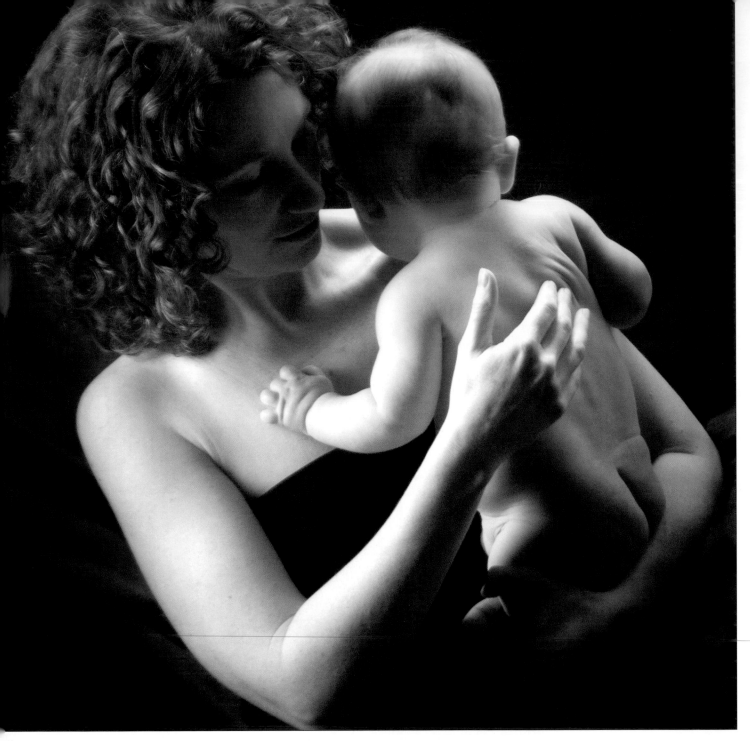

Above—Plate 3.48. **Facing page**—Plate 3.49.

In the image shown in plate 3.48, Jody challenges conventional lighting technique by producing an image with numerous lighting patterns. There is high contrast, low contrast, and some elements in between, but the pose is very attractive, presenting us with a view of how mothers may typically hold their babies—a presentation we may not normally consider. We do not know whether the mother was leaning slightly to her right or Jody tilted the camera, but the diagonal line created makes the image very attractive.

Plate 3.49 (photo by Mark Laurie) presents another view with the mother and baby interacting, this time

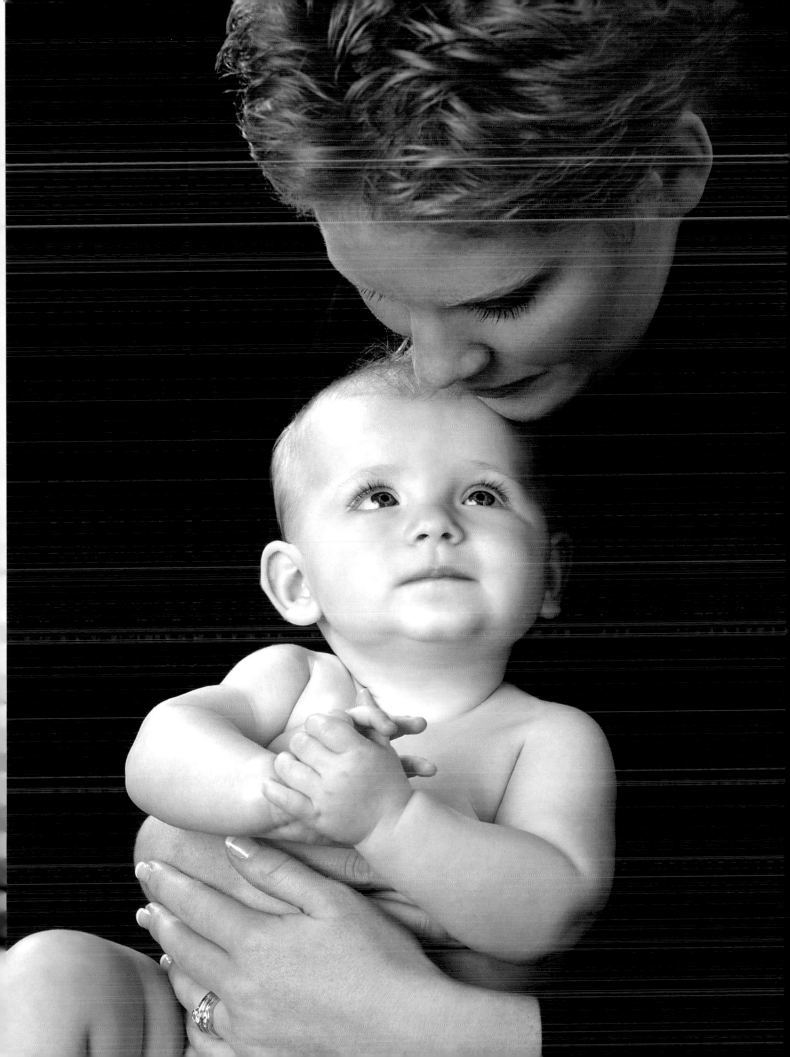

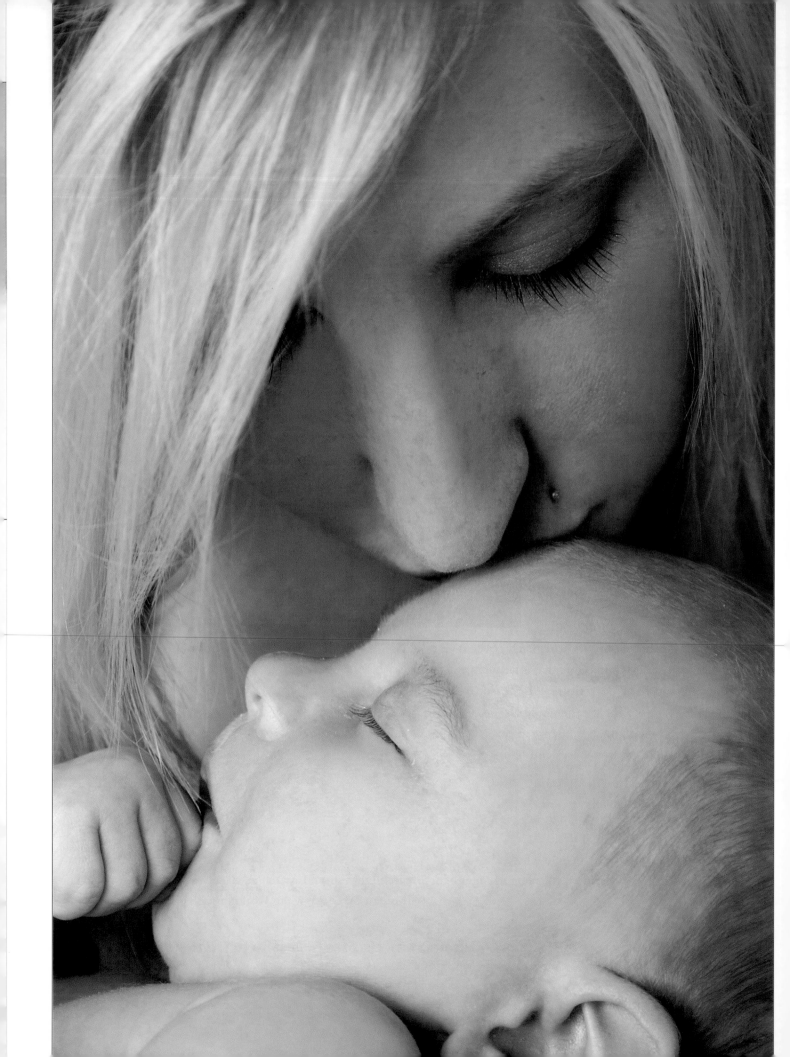

Facing page—Plate 3.53. **Right**—(top) Plate 3.54. (center) Plate 3.55. (bottom) Plate 3.56.

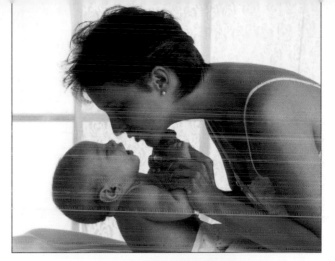

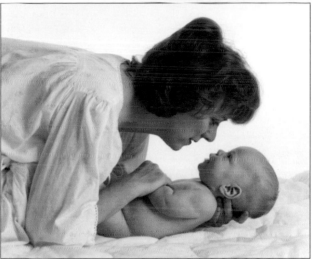

whose patience for photography may be short lived.

In plate 3.53, we see another portrait by Mark. This close-cropped image focuses our attention squarely on the connection between the subjects and the delicate kiss that the mom is giving her baby.

Mark again used his large softbox for a 2:1 ratio. The mother's hair blocked some of the light, changing the lighting pattern and producing a light ratio closer to 3:1.

The image in plate 3.54 (photo by Norman Phillips) is one that I have great affection for, as it was the first of its kind in our market. When it appeared in our window, crowds gathered to admire and discuss it.

The baby was positioned with his feet at the edge of a table so his mom could comfortably hold his hands. The mom was instructed to place her index fingers in his hands and wrap her other fingers around his forearms, lifting him up toward her. Part of the success of the image is that the baby was strong enough to raise his head. Many moms who came to the studio wanted to re-create the pose, but if their baby wasn't old enough to support his head, we had to use another pose.

A conventional high-key setup was used to light this portrait. The window set was positioned at the edge of the background, and the subjects were positioned in the center area of the set so that the background light would not spill onto them.

Plate 3.55 (photo by Norman Phillips) is a variation of the previous portrait. The posing is similar, and a conventional high-key set was used. The main light was positioned at 45 degrees off camera and subjects, at camera right. The subjects' position in the set allowed the fabric on which they were posed to blend into the background, ensuring a seamless transition.

Plate 3.56 shows a beautifully orchestrated portrait by Wendy Veugeler. There is an inherent delicacy in

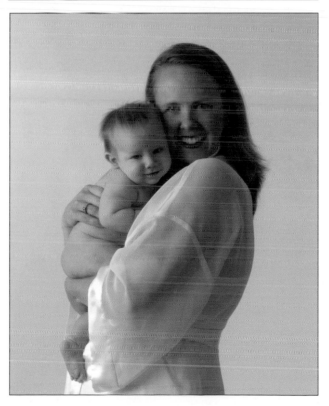

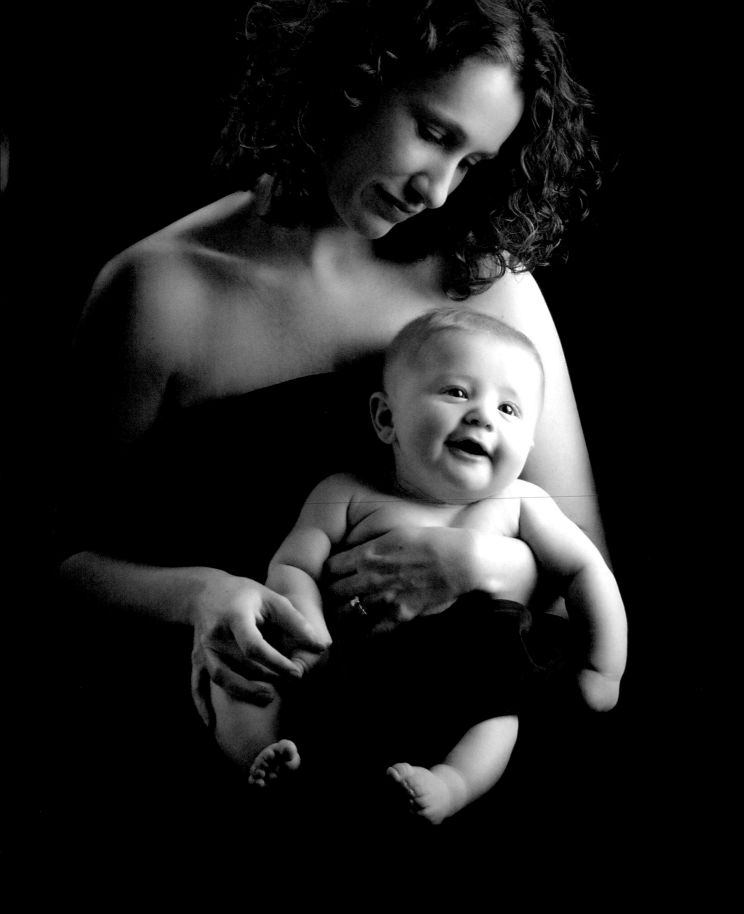

the image, as the baby's reaction to the camera is somewhat coy, and his mom is holding him gently but firmly and smiling widely. It is an example of a portrait that very much relies on the personalities of the subjects for its success.

The main light, a softbox, was placed at 50 degrees off camera and was feathered slightly so that the light skimmed across the baby's face, producing a 3:1 ratio. The light placement also created the desirable catchlights in the mom's eyes. Because the baby blocked some of the light, the ratio on the mom is almost 4:1, but the mask of her face is correctly lit, which is a factor in the sense of depth.

The lighting ratio is stronger than most we have reviewed, creating a feeling of depth and beautiful skin tones. We can see skin tones through the mom's clothing, too; this helps to create separation between the subject and the backdrop. The fabric of her garment also reflects light, filling in the deep shadows on the baby's face. The fill light had just enough of an effect to hold the ratio at 4:1.

Plate 3.57, a portrait by Jody Coss, shows the mother and child posed almost square to the camera. The presentation of both subjects is very appealing. The baby is very happy with whatever is happening near the camera, and the mother is looking down with obvious pride.

The main light, a softbox, was positioned at 45 degrees off both camera and subjects and was feathered a little toward the subjects, producing highlights on the right side the baby and the mother's left arm.

Another softbox was positioned high behind the subjects. This created separation from the background, nicely shaped the mother's arm, and perfectly illuminated her hair. Slight fill came from a third light, placed behind the camera.

The placement of the lights created two separate lighting patterns and ratios. On the right, we have a very bright area with partially blown-out highlights,

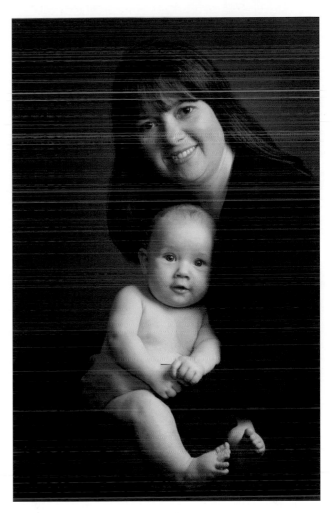

Facing page—Plate 3.57. **Above**—Plate 3.58.

and at the left there is a conventional 3:1 ratio on the baby and a 3½:1 on the mother.

Plate 3.58 is another portrait by Jody Coss. The posing created a gentle curved leading line that adds appeal in the image. The curved line breaks where the mother's head tips slightly to our left, and the baby is positioned at a slight diagonal from the bottom-left corner and toward the mother. This image illustrates a popular posing concept in which the child is seated on the mother's knee, facing the camera, and the mother is posed in profile.

Jody used broad lighting from the right to illuminate the broad side of the mother's face. The light threw some shadows onto her right side, but these did

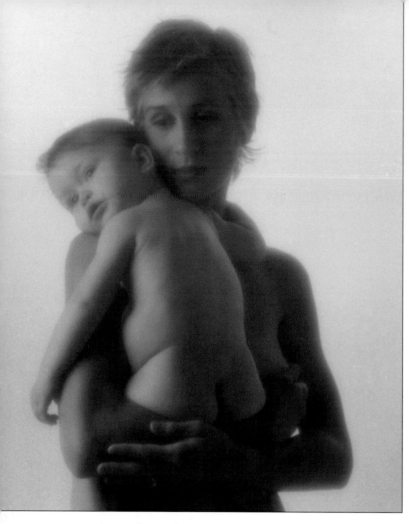

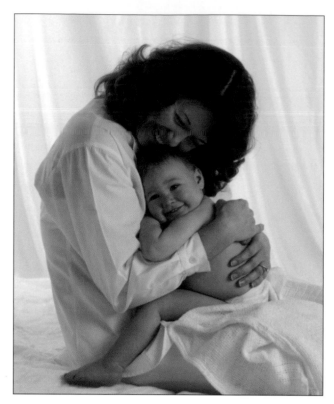

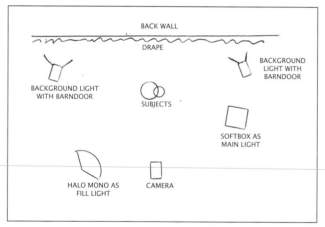

Above—Plate 3.59. **Top right**—Plate 3.60. **Bottom right**—Diagram for plate 3.60.

BACK WALL

DRAPE

BACKGROUND LIGHT WITH BARNDOOR

BACKGROUND LIGHT WITH BARNDOOR

SUBJECTS

SOFTBOX AS MAIN LIGHT

HALO MONO AS FILL LIGHT

CAMERA

not diminish the structure of the lighting pattern. The baby was perfectly illuminated by the main light and a fill light from behind the camera. Jody also used a background light to create separation.

Plate 3.59 (photo by Norman Phillips) shows a portrait that is one of my all-time favorites, despite the fact that I missed out on my own hand posing discipline. The portrait has a sense of peace and serenity, with both mother and child in a zone of their own. The mood was created by having one to two minutes of silence in the camera room.

Both subjects were so comfortable that they could have stayed in this position for much longer. This is a variation of a pose we have seen previously. This time, the child's back is to us and her right hand is wrapped around her mother's neck, with her left arm slung passively at the side. The baby's head is comfortably resting on her mother's shoulder, and her face is turned toward the main light. The mother is turned in the same direction to ensure an effective lighting pattern. The position of the mom's right hand is not the most flattering, but as the hand is covering her breast, the pose works.

The main light was a recessed, double-diffused medium softbox, placed at the mother's head level and

feathered toward the camera so the light was focused on the subjects' faces. This resulted in a 3:1 ratio on the baby and a 3½:1 ratio on the mother.

A Tallyn #3 diffuser filter was placed on the lens. This added to the dreamy feel the image conveys.

The image shown in plate 3.60 (photo by Norman Phillips) is the happiest mother and child portrait I have ever created. The pose is simple. The ten-month-old sat in his mom's lap with his legs astride hers, and his mom hugged him. The composition is delightful, with curvaceous leading lines that run from the boy's left leg to his midriff, then up to his head. The line breaks away at the point where his mom's head drops onto his.

The lighting set is a standard high-key set with the main light from the right. There is a 3:1 ratio, except where the mother's face is tilted downward and slightly falls into shadow and a 3½:1 ratio. A drape was suspended against the background wall to soften the otherwise harsh white background. See the diagram for plate 3.60.

The image in plate 3.61 is in stark contrast to the one we just reviewed. Mark Laurie set his subjects in a low-key set and used a large softbox close to the left of the camera, creating a 1:1 lighting pattern similar to glamour portraiture, which is one of Mark's specialties. When we describe a portrait as having a 1:1 ratio, we are in fact describing an image that is flat lit.

To add to the concept of creating a flat-lit portrait, Mark also had his subjects square to the camera and then employed a hair light from just behind them. This cast light on the mother's hair and shoulders and ensured tonal separation from the background. This light illuminated the mother's hair perfectly. Often when such a set is used, the hair is not illuminated as sharply as we see here. The eyes of both the mother and child are well defined and seem to communicate with the viewer.

Right—Plate 3.61.

Mothers with Children One to Two Years Old

The previous chapter is one of the longest I have written for any of my books, and this is simply because portraiture of children under a year old, alone or with their mother, dominates our market. Parents tend to gradually reduce their visits to our studios as their children grow older.

In this chapter, we will take a look at various poses and lighting setups that can be used with older children. Even though the number of clients in this demographic who visit our studios declines, we must be aware of the many strategies we can employ to create heirloom images.

The portraits shown in plates 4.1–4.4 are low-key images from a portrait session conducted by Mark Laurie.

In plate 4.1, we see how beautifully the subjects' skin tones are rendered against the dark clothing and set. The pose is simple and delightful, with the subjects interacting beautifully.

Mark lit this portrait with a 4x6-foot softbox placed close to the left side of the camera. A hair light set to the same power as the main light was positioned slightly behind the top of the subjects' heads. The exposure was calculated to show texture in the subjects' clothing. This rendered their skin slightly over-exposed. This is a look that glamour photographers cultivate on a regular basis, and they often carry this technique into other styles of portraiture.

In plate 4.2, Mark used the same lighting setup but turned his subjects toward the camera, with the mom's left arm around her daughter. The little girl expressed her interest in the goings-on behind the camera, and her little hands show her reaction. We can determine the placement of the main light in the set by noting the position of the catchlights in the subjects' eyes.

In plate 4.3, we see a minor adjustment in the pose, as the subjects turned toward one another for a kiss. A key element in this image is the joining of the hands immediately below the center of the composition. The hands are delightful and add to the magical feeling of the shared moment. Mark did not modify his lighting setup for this portrait.

Plate 4.4 was also photographed using the original lighting setup. Mark simply had the little girl change her position so she could snuggle against her mother's left shoulder.

These four images are an example of how we may offer parents a sequence of images that could easily be incorporated in a collage or framed as a sequence.

Top left—Plate 4.1. Top right—Plate 4.2. Bottom left—Plate 4.3. Bottom right—Plate 4.4.

Facing page—Plate 4.5. **Right**—(top) Plate 4.6. (center) Plate 4.7. (bottom) Plate 4.8.

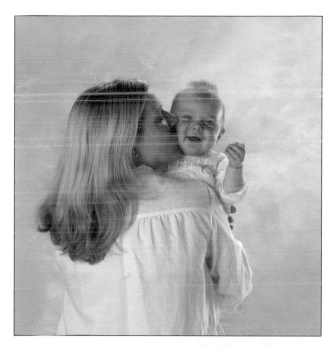

The next portrait, plate 4.5 by Wendy Veugeler, is in stark contrast to the four preceding images, as it is in high key and in color.

Wendy had the mom seat her baby on her right thigh. This prevented her from being directly under her mother's chin and ensured a nice composition.

The backs of the mother's hands are shown to the camera, but they are well presented. This proves that we can sometimes break the rules and make it work. Note that the camera was positioned slightly to the subjects' right. This presents us with a more flattering view than we would have had if the camera were positioned more perpendicular to the subjects.

Wendy used a conventional high-key set, with the main light to camera left. There is a light ratio of slightly less than 3:1. The exposure was spot on, and perfect skin tones are Wendy's reward.

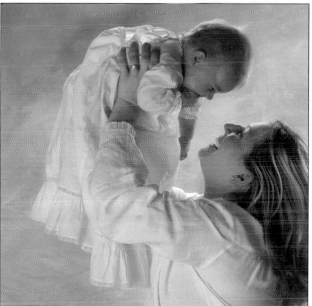

Next, we have a three-image set by Terry Jo Tasche (plates 4.46–4.48). *(Note:* Plate 4.46 appeared earlier in this book, but we will discuss it in terms of producing and selling a sequence of images here.)* All three images are similar—each portrait was made in high key and shows the mom and child engaged in a playful interaction. We should note that a trio of images like these might be presented in a single mat and framed. They offer a great storytelling quality that parents will adore.

Each image is distinctly different and has its own personality and perspective. The joy that the child is expressing is priceless, and it is clear that her mom is thoroughly enjoying the session as well. The subjects are not interacting with the camera. These moments are all about the love they share. One of the keys to retaining clients is that they enjoy their portrait session. From the emotion shown here, we can assume that these clients will be back for more portraits.

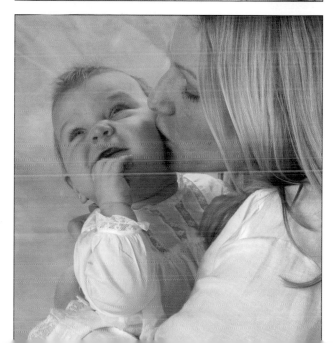

To light this trio of images, Terry used a large soft-box 45 degrees to camera left. Her hair light and accent lights added a lot of sparkle in the first two images, and in the third image she captured a precious moment where the child is leaning back in ecstasy.

Plates 4.9–4.12 (all by Norman Phillips) were created during a single session. I invited the mother to have fun and present herself in a manner in which she felt comfortable. She was quite bold and not afraid to show skin, so we created some beautiful images that many moms would not allow. The garment she was wearing was not very secure, but this didn't bother her, so we took full advantage of the opportunity to capture complementary skin tones of both mother and child.

In plate 4.9, the mother is presented in profile to the camera, and the child is naked at her chest with his head at her chin. The back of the mother's hand was pulled away from the camera so we see only her fingers. She was turned away from the main light, which was positioned at camera right. This resulted in broad lighting of her face. The child was fully illuminated in just over a 2:1 ratio. The subjects were positioned just on the edge of the center portion of the set. At this position, the background light added illumination on the child's face and the mother's right side.

The mother shed the garment she was wearing for the image shown in plate 4.10. She was seated on the floor with the infant in her lap, her right knee up, and her foot on the floor. She held her child's foot, and this ignited the child's curiosity, so he looked down to observe his foot. The mom's left hand shielded the boy's pelvic area from view.

There are two elements of the image that I would modify, given the chance. The angle of view of the mom's left knee presents a foreshortening of her leg, and the position of her right hand is not ideal. Had I modified my camera angle, I could have avoided both

concerns, but I was consumed with the child's curiosity and did not want to miss my opportunity to capture the image.

In plate 4.11, I redeemed myself by posing an almost perfect presentation. I placed a couple of pillows on the floor and covered them with a soft fabric. I had the mom lay on her tummy with her arm across the plane of the pose and had the child positioned next to her on his tummy. I asked the mom to drape her left arm around him to ensure he stayed in place. This also emphasized the bond between the two. We then arranged her hair so that we could see how beautiful it is. Her fingers and hands were carefully posed to achieve the best-possible presentation. We created enough entertainment to hold the child's interest.

In plate 4.12, we simply posed the mother profile to the camera and allowed her to interact with her son. The lighting was from a high-key set. The setup is illustrated in diagram on page 58 (minus the drape).

The portrait in plate 4.13 (page 66; photo by Sarah Johnston) offers us an unconventional view of an over-the-shoulder pose. Sarah's camera angle was slightly above the mother's head looking slightly downward at the child. The tight crop does not allow us to see much else of either of the subjects, and the focus is primarily on the little person. Based on the notion that there is nothing more beautiful than a sleeping baby, this image is spot on.

The lighting is from two softboxes to the right of the camera. One illuminated the back of the subjects and the other provided the modeling seen on the child's face. Sarah's primary lighting setup is shown in diagram for plate 2.12 (page 14).

When we reviewed the image shown in plate 3.54 (page 55), it was noted that not all babies will have the strength to lift their heads for that pose. In plate 4.14 (page 66; photo by Norman Phillips), we have a similar pose that was modified to get the child up close to her mother. This time, the mom held her baby's

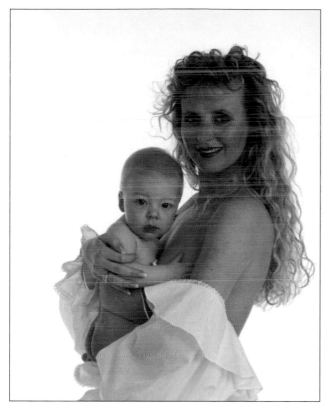

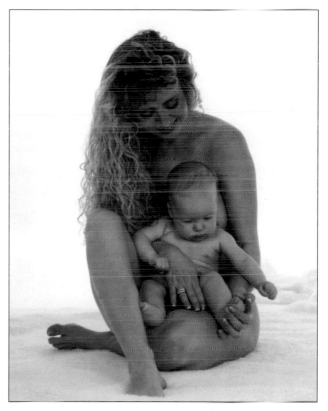

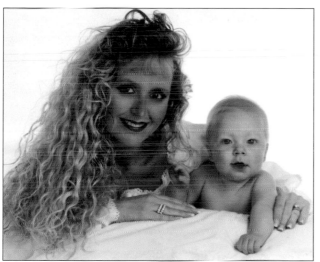

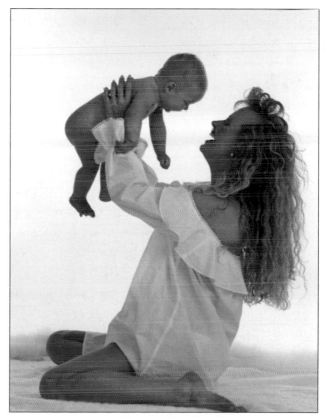

Top left—Plate 4.9. **Top right**—Plate 4.10. **Bottom left**—Plate 4.11. **Bottom right**—Plate 4.12.

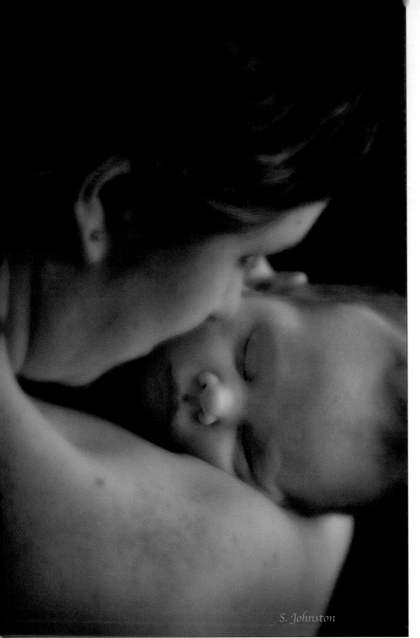

S. Johnston

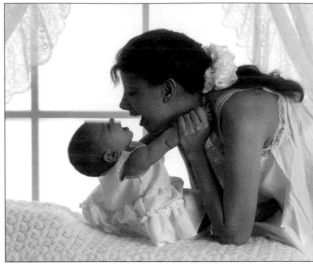

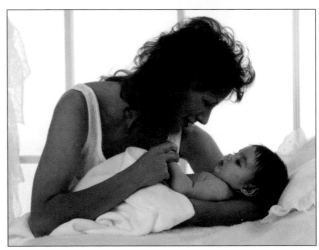

Left—Plate 4.13. **Top right**—Plate 4.14. **Bottom right**—Plate 4.15.

forearms and drew her upward. Because the infant couldn't gather the strength to raise her face to meet her mom's, we compensated by having her mother raise her that much closer. In doing so, we created a different composition in which leading lines were formed by the subjects' arms.

A standard high-key setup was used. The main light was placed at camera right. It created a 3:1 ratio on the mother and a 1:1 ratio on the child.

The young child shown in plate 4.15 (photo by Norman Phillips) was very relaxed and comfortable in his position on his mother's arm. The mother held his left hand and communicated with him.

If I were able to modify this pose, I would reposition the mother's left arm, as the way that it is cropped is less than flattering. Alas, the flaw was a result of meeting another objective: using the blanket to cover the baby's pelvic region.

A standard high-key set was used to create this portrait. The main light was positioned at camera right, and a window set prop and drapes were used as a high-key backdrop.

Plate 4.16 (photo by Norman Phillips) is a portrait in a very different style. The mother was posed on the floor, with her knees positioned so that her legs cradled her son. To help keep the little guy in the desired

position, his mother had her hands around his legs, and the teddy bear he relates to was placed in front of him. We can see that the mother was trying to encourage junior to engage with the camera, and even though his expression does not match hers, the image is quite attractive.

The lighting used in this image was from a standard high-key set, with the main light at a little more than 45 degrees off camera right. There is a 3:1 ratio in the image.

The image shown in plate 4.17 (photo by Sarah Johnston) is quite interesting. The child was unable to stand on his own, so his mother held him upright. The leading lines created by mother's arms—and the way they link with junior—compel us to examine the image from the top to the bottom and back up again.

The overall image cropping, and the decision to crop so close to the child's face, makes for an intriguing portrait.

The main light was positioned at camera right and just behind the subjects' position. This set is the same one shown in Sarah's other images, but this time she used a high-key backdrop.

I was not going to include the portrait in plate 4.18 (page 68; photo by Vicki Taufer) because there is so little of the mother to be seen, but I found the image irresistible. The posing is perfect, with the mother's feet clearly in view and evenly spaced around the child.

Window light and a lovely 3:1 ratio beautifully rendered the child. If we observe the shadow on the floor behind the subjects, we can see their position as it relates to the light. The mother was positioned just in

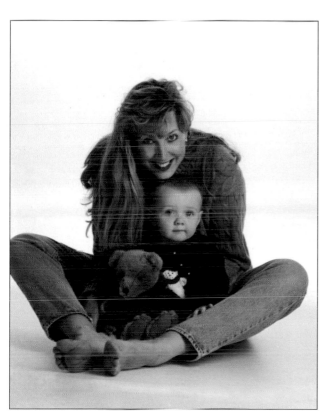

Left—Plate 4.16. **Right**—Plate 4.17.

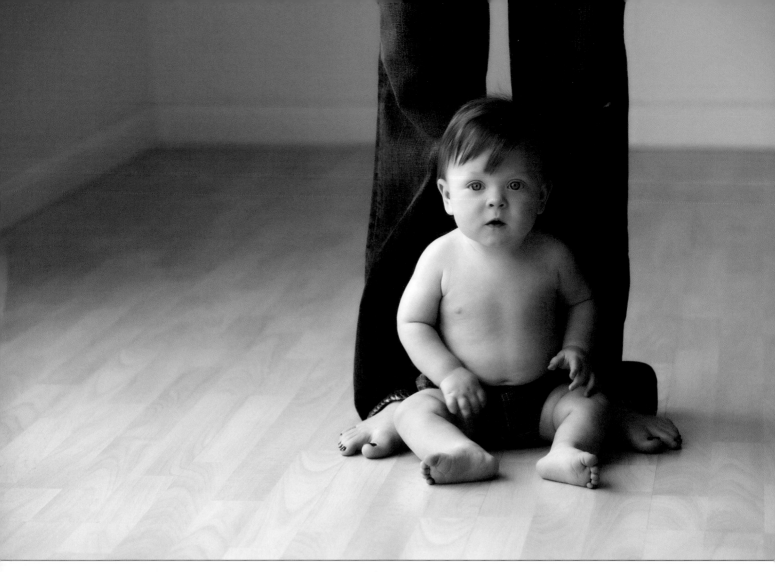

Top—Plate 4.18. **Bottom**—Plate 4.19.

front of the line where the edge of the window and the wall meet. This is confirmed by the shadow at her left leg, which shows the trajectory of the light.

The exposure is spot on. We are able to see lots of great skin tones, and the eyes of the child pop out at us. The mother's jeans show texture too.

Plate 4.19 (photo by Terry Jo Tasche) is a portrait of a happy little boy enjoying his ability to stand, even if he needs his mom's help to stay upright. The expressions are delightful. Little people learning to stand or walk will always allow us to create such a portrait.

A large softbox to the right of the camera served as the main light. It produced an accent light on the mother's hair and arm and a little on the boy's face. It also created a little hot spot on the mom's left cheek and shows us where the light was positioned, a little

over 45 degrees off camera. A fill light was used to open up any deep shadows created by the slightly oblique angle of the main light.

The use of a textured pastel backdrop is a nice change and softens the overall impression.

In plate 4.20 (photo by Norman Phillips), both subjects are nude. The mother was posed in profile and very slightly turned away from the camera to ensure that any unexpected movement would not produce an inappropriate view. The little boy was cradled in his mom's arms, and something between his mom and the camera held his attention. The mother was asked to get cheek to cheek with her son to produce yet another modification of a popular pose.

A standard high-key setup was used. This resulted in a 1½:1 ratio on the child and a 3:1 on the mom, partly because the little boy blocked a little of the light.

It is not known what it was that Michael Ayers did or said that resulted in the child's great expression in plate 4.21. Michael posed his subjects with the mother's left shoulder behind her son so that she could comfortably nestle her head close to him. Her angle to the camera caused her to be in a three-quarter view, and the child is in a similar view. The concept is simple,

with the boy standing in front of her. The view is different from any of the previous poses we have seen in this style.

A suspended softbox positioned at 45 degrees at camera left provided the lighting. An umbrella suspended from the ceiling behind the camera at roughly the same power as the main light provided the fill.

Most photographers aim to create light ratios of 3:1 or 3½:1 in their portraits. This image has a 2:1 ratio, which is a hallmark of Michael's style, and he rarely departs from it.

Veena Cornish created the portrait in plate 4.22 on a high-key set. The uncommon composition was the result of the baby pushing her feet against her mom, thereby positioning herself at the opposite side of the frame. The space between the two subjects causes us to look from side to side to view the expressions on both faces. Note that the mother retained control, as she had her hands behind her daughter.

Veena posed her subjects profile to the camera and planned to document the interaction between the two. Instead, she captured the expression of a curious little girl and her mom enjoying the moment.

The image was created on a high-key set with the main light positioned to camera left. The mother is rendered in a relatively flat light, but the child is shown in a 3:1 ratio because she was turned toward the camera.

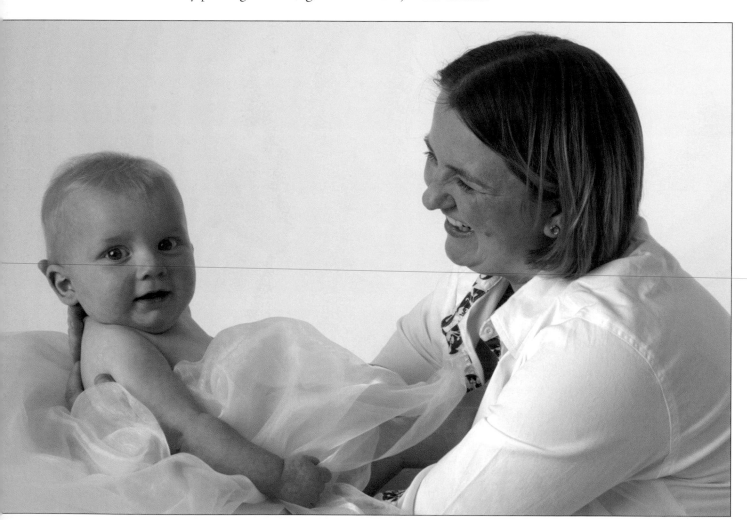

Above—Plate 4.22.

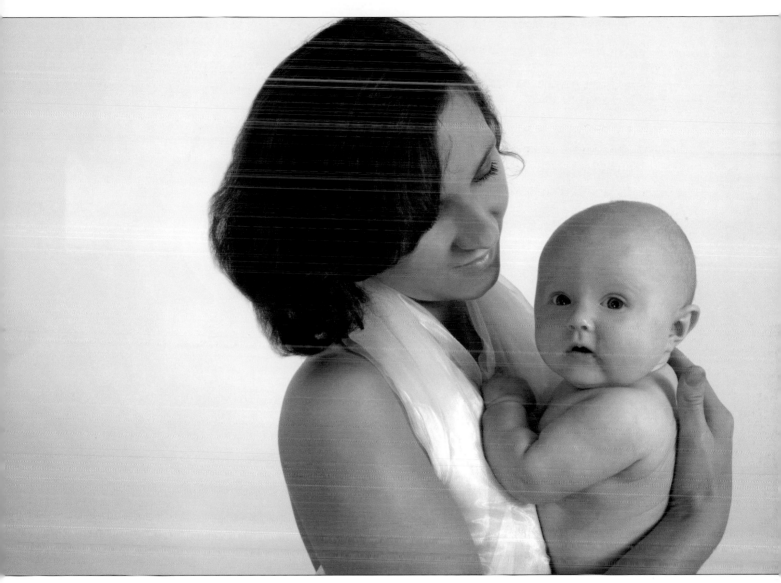

Above—Plate 4.23.

Plate 4.23 is another portrait by Veena. It was made on the same high-key set, but this time the main light was on the right. The child's body was held against her mom's, but her head was turned toward the camera. The mom simply adored her child. The mom's supporting hand, placed at the baby's back, was well posed. We see the side of the hand, which is the preferred view.

The lighting created nice skin tones with gentle gradation from highlight to shadow. There are no deep shadows, which would change the ratio of 2½:1.

The modeling of the child is excellent and that of mother is very pleasing. The image is representative of quality high-key in black & white. The impression is sensitive and flattering, showing both the child and the mother in a delicate tonal range.

An interesting technical point is that the child's position as she relates to the main light caused dark outlining on her mother's cheek and chin. This is further emphasized because the portrait is presented in black & white.

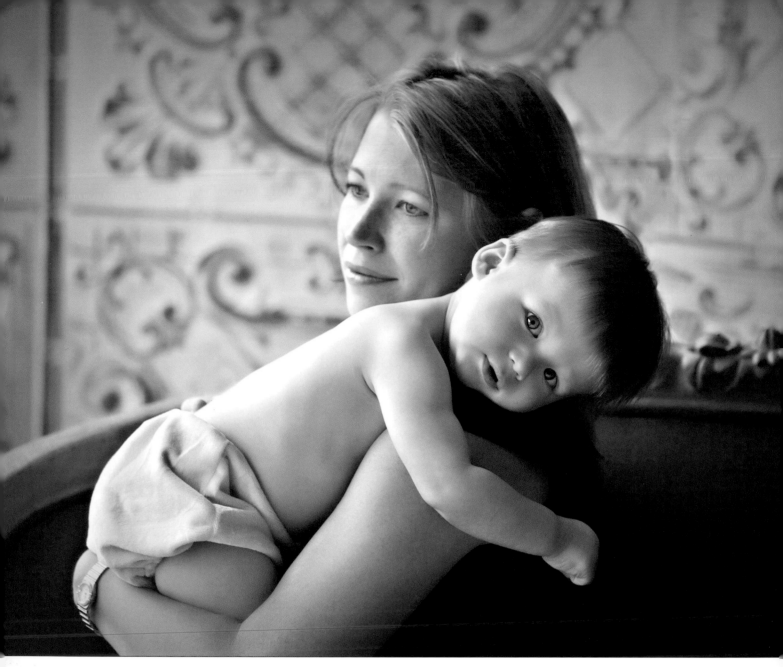

Above—Plate 4.24.

Plate 4.24, by Vicki Taufer, shows another over-the-shoulder pose. In this image, the child is positioned higher on the mother's shoulder, and we see him fully engaged with the camera. The portrait has two distinct impressions. One is the delightful, questioning expression on the child's face, and the other is the dreamy expression on the mother's.

To light this image, Vicki relied on window light from camera left. The distance from the window was key to the way the subjects were illuminated. Often-times subjects are positioned too close to the window and are consequently lit with too much contrast. Here Vicki positioned her subjects a little farther into the room and the light. The light is more diffuse and wraps around the subjects to a greater degree.

A second window, or perhaps a reflector, added a little fill light to the portrait.

The angle of the subjects to the window produced a 2:1 ratio. This ratio could have been greater had they been turned slightly toward the camera.

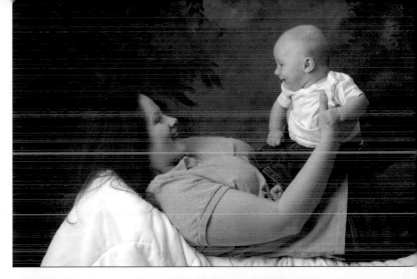

The portrait in plate 4.25 (photo by Norman Phillips) proves that the clothing advice we offer clients does not always register. The mom and her son were dressed in t-shirts and jeans. This met her desire for a casual portrait but did not allow me to flatter her, as I would have preferred.

The boy was seated on his mom's tummy, and she playfully interacted with him.

The pose in plate 4.25 paved the way for the one shown in plate 4.26. The boy was brought over to his mom's cheek. This allowed me to crop the mom's arm and present a more flattering view. This pose works well whenever a mother and child are dressed in a relaxed style.

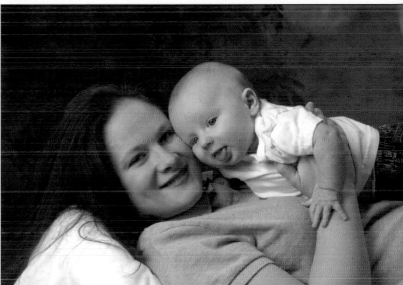

A 28x42-inch, single-diffused Westcott Recessed Apollo Mono was placed at 50 degrees off camera left. A single-diffused, 12x36-inch Westcott Stripbank was used as a hair light. A third light, a 45-inch Westcott Halo Mono, bounced off the right-hand wall, was used as a fill light.

Vicki Taufer is a master of color harmony. In each of her images, there is a smooth transition from her

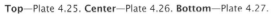

Top—Plate 4.25. **Center**—Plate 4.26. **Bottom**—Plate 4.27.

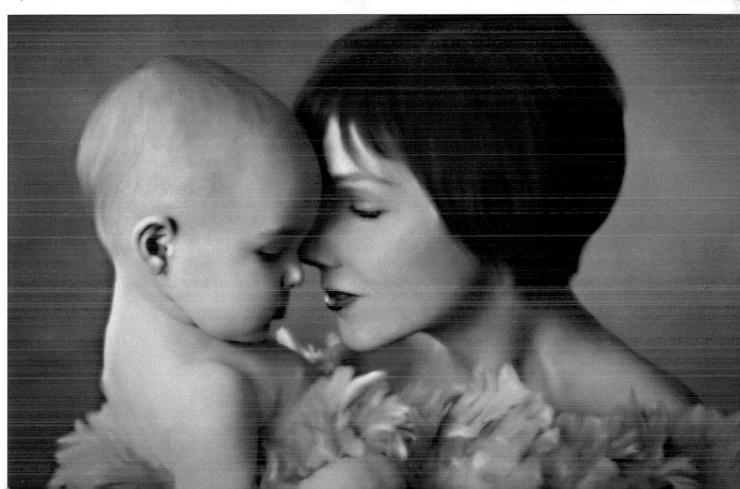

subjects to the rest of her set, and the image in plate 4.27 is no exception. There are no colors that conflict or jump out at us—all of the colors harmonize.

The pose was beautifully arranged. The child was at just the right height, which allowed the mother's nose to fit into the contour of the baby's face. This resulted in a fabulous jigsaw-like pattern. Both subjects are presented in perfect profile to the camera, and there is a sensitive feel to the portrait. This impression is usually accomplished by allowing silence to reign for a few moments before capture.

A single-diffused softbox to camera left served as the main light. Vicki also used a hair light at approximately 1½ stops less power than the main light. A fill light powered to ½ f-stop of the exposure of the main light was positioned behind the camera. The result is a smooth transition through the skin tones and a 3:1 ratio.

Below—Plate 4.28. **Right**—Diagram for plate 4.28.

Plate 4.28 (photo by Michael Ayers) presents us with a unique impression. The portrait was created with a soft-focus filter, and the effect adds to the portrait's appeal.

The close cropping Michael used prevents the sale of a large portrait, as any size over 11x14-inches will cause the heads of the subjects to be larger than life. Presenting heads in a portrait that are more than 5 percent larger than life size is not recommended.

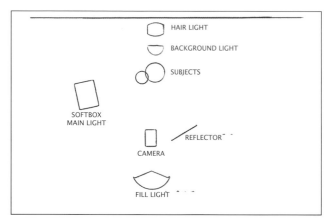

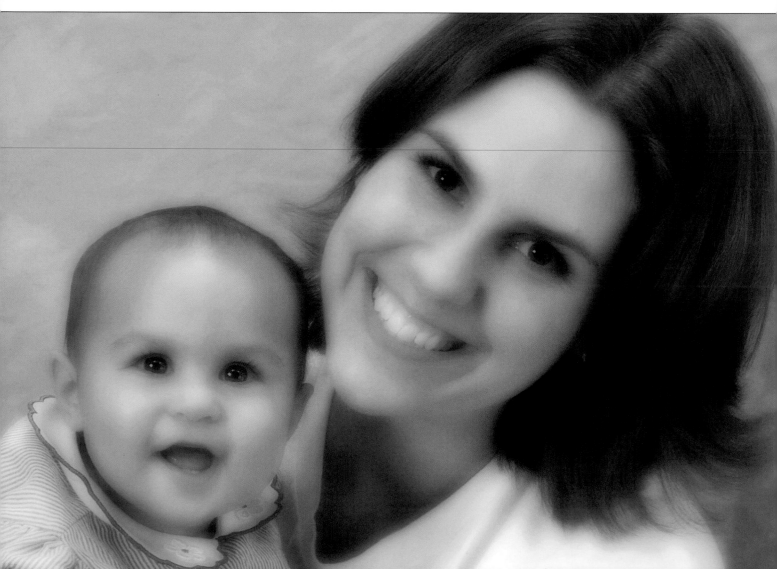

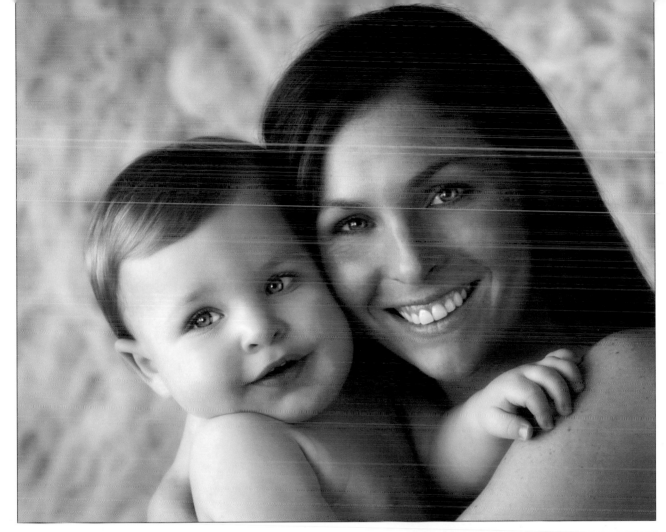

The composition is appealing. The young child is in the left third of the frame, and the mom's eyes are in the top third of the composition. The mom tilted her head to our right, and this added impact. The sparkle in the subjects' eyes heightens their happy expressions. The multiple catchlights in the tot's eyes are the result of the three lights in front of her and the reflector. The mom's eyes show one bright catchlight and one barely visible catchlight because she was angled away from the fill light and the reflector.

Michael used a softbox at camera left as his main light, an umbrella above the camera as his fill light, and a hair light high on the backdrop. A reflector was used a little to camera right to soften the image a bit. A background light was placed behind the subjects at an exposure of f/5.6. See the diagram for plate 4.28.

The portrait in plate 4.29 is another adorable image by Vicki Taufer. In this image, we again see the excel-

SOFTBOX WITH FOCUS CONTROL ACCESSORY OPENING

Top—Plate 4.29. **Bottom**—Diagram for plate 4.29.

lent color harmony. The subjects' sparkling eyes command our attention. As the eyes are regarded as the window to the soul, creating images in which the eyes are beautifully portrayed is an important goal.

The angle at which the subjects are presented is different in this head-and-shoulders portrait than in plate 4.28. Here, the subjects' heads are tilted to our left, and the child's left hand is placed at her mother's shoulder.

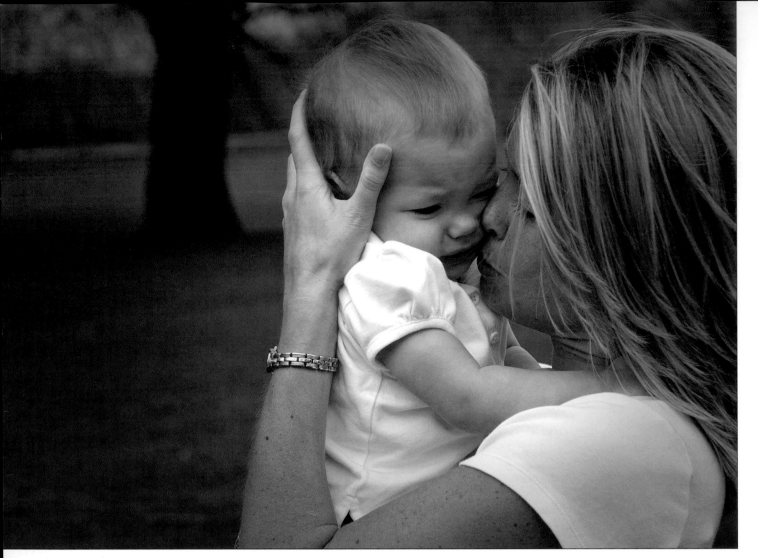

Above—Plate 4.30.

The main light was a softbox, set at camera left and at 45 degrees off camera and subjects. It was feathered slightly toward the camera, with the bottom edge level with the child's shoulder. The fill light was a softbox behind and a little to the right of the camera. A hair light was used to highlight the hair and create separation, and a background light ensured even coverage of the background and kept it in middle key.

The child's skin tones are a bit blown out, so there is little detail on her right side and on her hand. To avoid this, we can attach a diffusing panel on the softbox (black fabric with a large circular opening). This helps to focus the light on the subjects. Also, the covered areas of the softbox will give off a softer illumination that will prevent areas of the scene that are closest to the light from being overlit. See the diagram for plate 4.29.

Michael Barton does not regularly position his subjects in the center area of the frame, and in plate 4.30, we see them on the right side of the composition. This image proves that empty space can be a positive photographic element. Here, the open space on the left draws the eye to the subjects on the right.

The pose and the emotion in the image are natural and show the mom's efforts to soothe her child. The mother's left hand is holding the child's head. Whether the gesture was spontaneous or coached, it is a nice touch.

The lighting is pure daylight. The photographer captured the image when the light was sufficiently dif-

fused. The subjects were positioned near a natural backdrop that was one f-stop darker than the light on the subjects.

Plate 4.31 (photo by Mark Laurie) shows a completely different approach to mother and child portraiture. Mark took advantage of the natural desire of a toddler to exhibit his climbing skills and allowed the little guy to interact with his mother at the top of the stepladder. The kiss added a nice touch that allowed the subjects to come together. The dog does not look too interested, or perhaps he is a little anxious about being perched atop the ladder.

The portrait was created on a high-key set. The main and fill light were at the same power (or close to it), and this resulted in a 2:1 light ratio.

In the Terry Jo Tasche portrait shown in plate 4.32, we have the child held at his mom's shoulder. The tot was raised up so that his head was above his mother's, and it is only because the mother tipped her head so that his eyes are at the same level as hers. This resulted in a better, more dynamic feel than is found in images in which junior is at a lower level to his mother.

Terry used a softbox to camera left and at 45 degrees off the camera and subjects, with its bottom edge level with the mother's hips and slightly tipped downward to create the tight modeling of the subjects' features. The position of the light is seen in the catchlights in the eyes.

Terry used a hair light positioned high on the background. An accent light was placed slightly behind the subjects' position at camera right. To fill in shadow areas, Terry used an umbrella positioned above and behind the camera.

We will wrap up this chapter by reviewing an image that was nearly cut from inclusion in this book. In plate 4.33 (page 78; photo by Michael Barton), we have an image that is strikingly different from the style of images presented in the balance of this book. I de-

Left—Plate 4.31. **Right**—Plate 4.32.

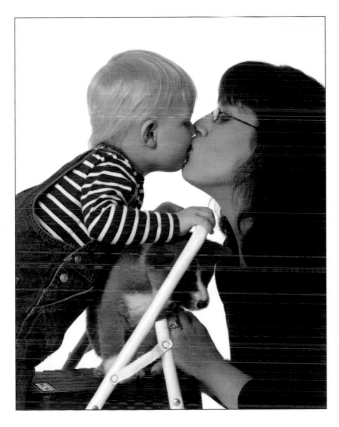

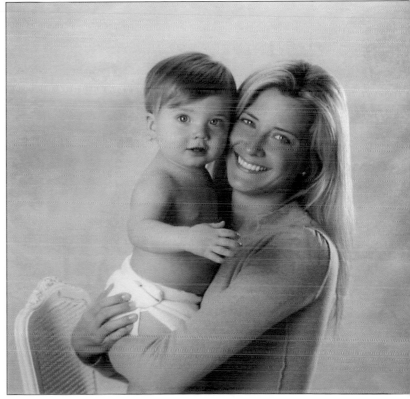

image is more polished and worthy of display.

Photographer Michael Barton created the two striking portraits shown in plates 5.3 and 5.4. In plate 5.3, we see an example of Michael's inclination toward the creative use of space. This is quite unique. I cannot recall seeing more than one or two examples in which photographers challenged the conventional compositional approach of keeping the subjects in the center third of the frame. By posing his subjects on the right-hand side of the composition, Michael ensures that our eyes are drawn across the portrait.

The clipping of the side of the child's head also defies convention, and advocates of traditional portraiture would frown upon this. Creative cropping is often used in contemporary portraiture, though, and is commonly seen in advertising photography. Here, the crop-

Michael Ayers created the portrait in plate 5.2 with his basic studio lighting setup shown in the diagram on page 74, minus the background light. True to form, Michael created a relatively even lighting pattern that is a little over a 1½:1 ratio.

The subjects are casually dressed, and the pose Michael chose suits their attire. The mother was positioned over the boy's shoulder in the peek-a-boo style, in which a parent comes from behind to be cheek to cheek with the child. We often see this pose in candid shots, but with professional lighting, the resulting ping works well, as it makes the eyes a more dominant element in the image.

Another reason for the portrait's success is the inclusion of the child's fingers. They create balance in the composition and are cropped at just the right place.

This is a great portrait that breaks many established rules to great effect.

Michael illuminated the subjects using a large softbox at 50 degrees off camera left. A reflector was used to the right of the camera and added fill light.

Plate 5.4 is another example of the way Michael Barton challenges the conventional use of space. Here, Michael moved to his right to position the subjects at the left edge of the frame. He backed up to show more of the length of his subjects' bodies and had the mom and child tip their heads just slightly more toward the right.

This is an especially creative concept. The effect of this use of space causes us to view the subjects, and then our eyes wander to the right-hand portion of the frame and back to the subjects again.

Michael did not change the lighting setup when he created the second image in this series. However, because the camera position was changed and the subjects were turned away from the main light, the lighting pattern changed. The mother is now rendered in a 3:1 lighting ratio instead of the 2½:1 ratio in the previous portrait, and the modeling on the child has become more prominent.

Terry Jo Tasche created the portrait shown in plate 5.5. The image exudes fun and excitement. Like Michael Barton, Terry used unconventional cropping and positioned the subjects at the right side of the frame. This treatment added impact to the image.

The portrait speaks volumes about the fun the mother and child were having as the image was captured. The mood is enhanced by the impression of motion, and the main light from our left lights up the subjects' expressions with an almost 3:1 ratio. A longer ratio would not create the same effect.

Terry used a hair light behind the subjects at an f-stop equal to the main light. This created a perception of depth in the portrait.

Top left—Plate 5.3. **Bottom left**—Plate 5.4. **Right**—Plate 5.5.

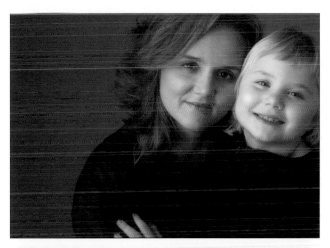

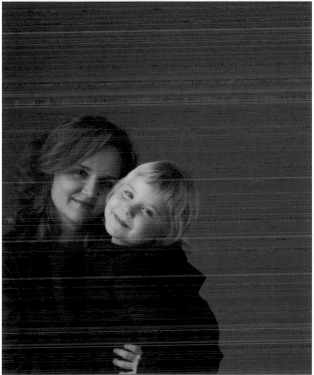

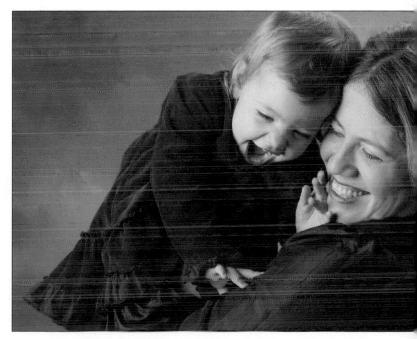

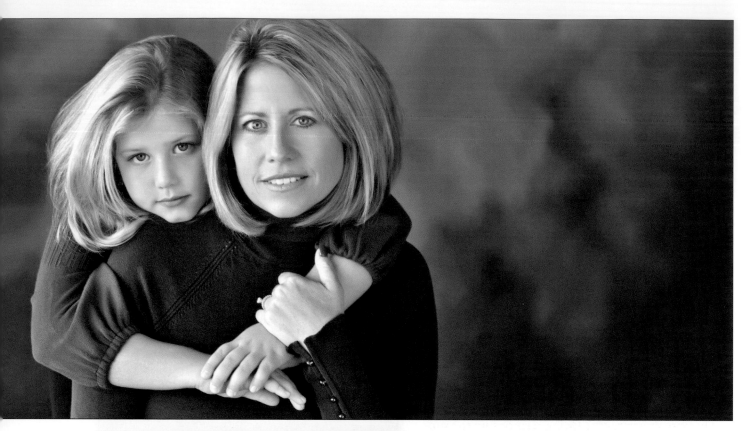

Top—Plate 5.6. **Bottom**—Plate 5.7.

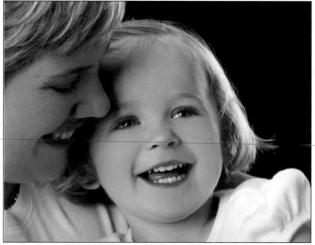

Plate 5.6 shows an image by Vicki Taufer in which the subjects are positioned in the left-hand half of the frame. Vicki's subjects are beautifully posed, and there is a nice circular line formed by the positioning of the little girl's arms, which are draped around her mom's shoulders. The mother brought her left hand up to rest on the girl's arm, intensifying the closeness depicted in the image.

There is very gentle modeling in the image due to the placement of a large softbox to the left of the camera. This rendered the subjects in a 2:1 ratio. We can determine the size and position of the light by the size of the catchlights in the subjects' eyes. The delicate rendering of the skin tones draws our attention to the subjects' eyes, and the sincerity expressed in the beautifully illuminated eyes makes this portrait very impressive.

The fill light was a large softbox placed behind and slightly to the right of the camera. It produced about half an f-stop less light than the main light and added a look of vitality in the eyes.

Mark Laurie created the portrait in plate 5.7, a tightly cropped image of two happy faces. The pose provides us with another idea for creating images that make a delightful keepsake for the family. Note, however, that the close crop limits the size of print we can

provide to our clients. At 11x14 inches (the size of the average computer monitor), the subjects' heads are 20 percent larger than life size.

The main light, Mark's preferred large softbox, was positioned at 45 degrees from the camera, at camera left. He used a second softbox slightly behind and to the right of the camera. This created the delicate rim light on the child's cheek and highlighted her hair. The eyes of the child are full of life and sparkle, and it is certain that the mother appreciated the image.

Veena Cornish created the delightful portrait shown in plate 5.8 on a high-key set with the main light, a medium, single-diffused softbox, placed to camera left. Veena's high-key set includes not only a white background but a white wall to the right of camera. The light on the set bounced off of the wall and illuminated the left side of the boy's face. Veena's studio has a relatively low white ceiling, so the set reflects a lot of light that can often substitute for a fill light.

The pose illustrates the loving relationship the subjects share. The boy was positioned behind his mom and wrapped his arms around her in an embrace, and the mother is shown holding both of the boy's hands. This is a very nice touch.

Left—Plate 5.8. **Top right**—Plate 5.9. **Bottom right**—Diagram 5.1.

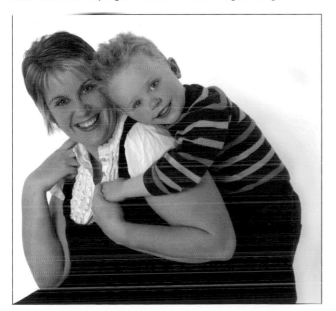

Plate 5.9 (photo by Norman Phillips) was created in our studio and was an extension of a pregnancy portrait session. My goal for this image was to photograph the child alone with her mom and to mask the mother's pregnant form. The girl was posed on her mom's right knee so the mother could draw her close to her shoulder. This created a diagonal composition of their figures. The subjects' arms rested passively in

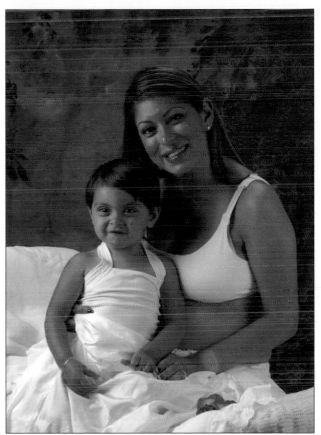

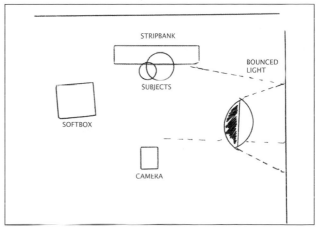

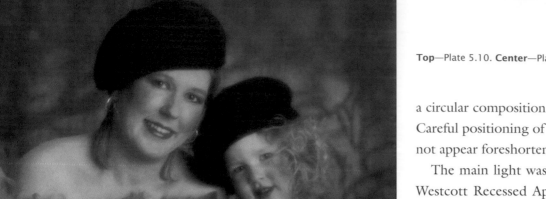

a circular composition and created nice leading lines. Careful positioning of the arms ensured that they did not appear foreshortened.

The main light was a 28x42-inch, single-diffused Westcott Recessed Apollo Mono positioned a little more than 45 degrees off camera and slightly feathered across the subjects to create definitive modeling in a 3:1 ratio. A 12x36-inch, single-diffused Westcott Stripbank was positioned with its leading edge immediately above the subjects' heads and provided the hair light. The light from a Westcott Halo Mono was bounced off the right-hand wall, adding fill light. See diagram 5.1.

The portrait in plate 5.10 (photo by Norman Phillips) was created during a studio glamour promotion in which mothers were encouraged to include their daughters. Makeup and hairstyling (provided by licensed practitioners) was included in the portrait session. We also provided the hats and boas, though a few clients brought their own hats.

The background was a nondescript painted canvas. A cookie was added to the spotlight to break up the lighting pattern. This produced the halo-type separation on the backdrop.

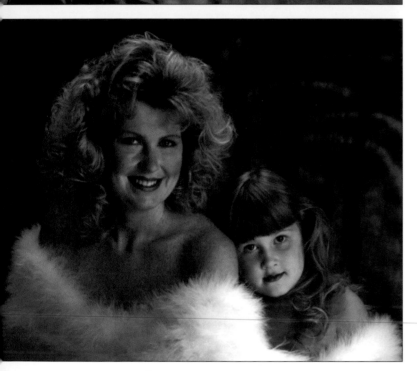

The subjects were posed square to the camera with the little girl positioned in front of her mother's left shoulder. This enabled the subjects to be presented with their heads close to one another.

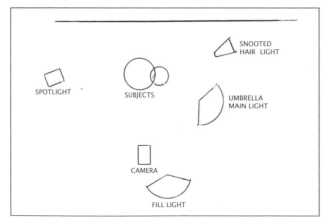

The main light was a 45-inch, soft-white umbrella placed 45 degrees off camera right and at the mother's head height. A second soft-white umbrella provided the fill light from behind and slightly to the left of the camera. A hair light was placed high to the right of the camera and behind the subjects to hold the hat color. The result is a soft 2½:1 ratio.

A Tallyn #1 soft-focus filter was used on the lens to create the soft, feminine effect.

Plate 5.11 (photo by Norman Phillips) is another portrait created during the same glamour portrait promotion. In this portrait, the mother's figure is turned away from the main light. She was turned toward the camera so that her daughter could rest against the back of her shoulder. This created an impression that differs from the one shown in the previous portrait.

A soft-white umbrella served as the main light. The light was feathered across the subjects' faces to create a 3½:1 ratio. This longer ratio created greater depth and stronger contrast than was achieved in the previous portrait.

A matching umbrella placed behind the camera provided the fill light, and a snooted light was used as a hair light. A cookie was placed in front of a spotlight to break up the solid, low-key canvas background. See diagram 5.2.

We ran another promotion at our studio in which our subjects were encouraged to wear hats. In plate 5.12 (photo by Norman Phillips), we see the first of two such images illustrated here.

The pose created two diagonals: one runs between the subjects' heads and the other runs through the mother's legs. The pose is something of a hybrid—both semiformal and casual.

The girl was facing the camera, and we encouraged her to kick her leg over her knee. Her mom was posed slightly profile and turned back toward the camera for a three-quarter facial pose. The full-figure composition allowed for the sale of a large wall portrait.

In plate 5.13 (photo by Norman Phillips), we have another image photographed using our high-key set. This time, we had the girl switch sides. We now see her seated on the white box in a three-quarter view. Our intent was to have her face the camera, but we were not quite able to pull it off. The mother's position was unchanged, except that we had her drop her weight onto her right hand, which was resting on the seat. This brought her head closer to her daughter's,

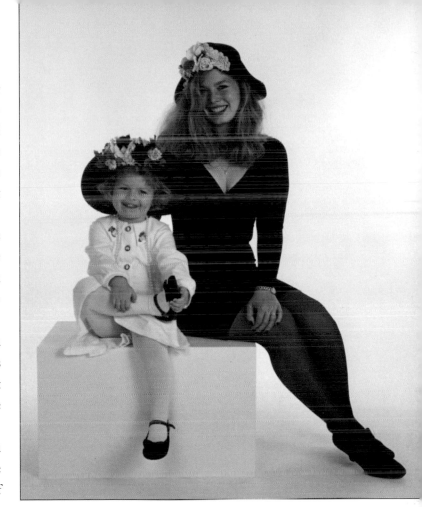

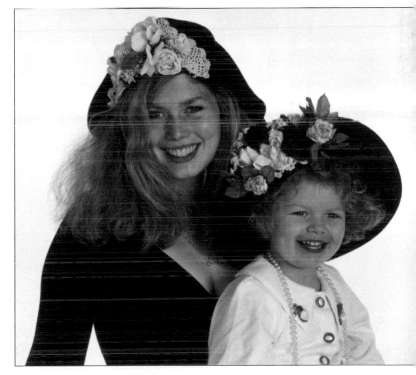

Top—Plate 5.12. **Bottom**—Plate 5.13.

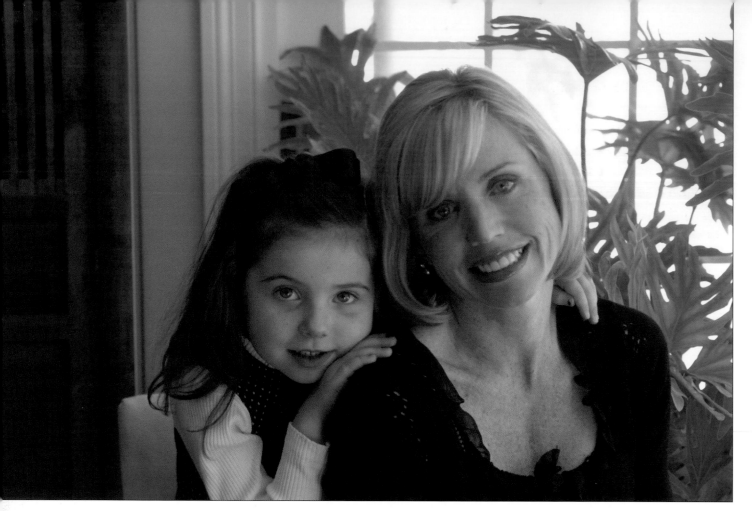

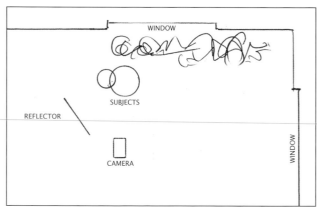

Top—Plate 5.14. **Bottom**—Diagram for plate 5.14.

retaining the diagonal line and bringing their hats together.

The portrait in plate 5.14 (photo by Norman Phillips) was created at the client's home. The light came from three windows, plus a reflector positioned to the left of the camera. The main light came from windows to the right of the camera, and fill light was from a window behind the camera. The window behind the subjects was calculated to provide an almost high-key background. It illuminated the plants behind the subjects with natural, wraparound light. See the diagram for plate 5.14.

The mom was seated and turned slightly toward camera right. Her daughter was positioned with one foot on the floor and her knee on the seat her mom was perched upon. This allowed her to rest her hands on her mom's shoulders and bring her cheek in close to her mom's face. The mom's head was then tipped toward her daughter.

Plate 5.15 (photo by Norman Phillips) was created in the client's home. The main light was a Metz MZ54 fitted with a Gary Fong Lightsphere. Window light from camera right provided ambient fill, ensuring illumination over the background and subjects. A reflector positioned to camera left added frontal fill. We achieved a very nice, even illumination across the set,

resulting in a 2:1 light ratio and beautifully rendered skin tones.

The mom and daughter were both presented in a seated pose, with the girl positioned slightly in front of her mom. The mom was turned slightly toward camera right. We brought the girl in close to her mom, bringing their faces together. This caused her to tilt her head and produced a pretty, delicate impression.

Plate 5.16 (photo by Norman Phillips) was created to show how enthralled my client was at reviewing the "Day in the Life" coffee-table book I created for her, which featured all three of her children. The portrait

Top—Plate 5.15. Bottom—Plate 5.16.

Above—Plate 5.17.

was created with ambient light in the family's living room. The light came from two floor-to-ceiling windows, one at camera left and one at camera right. The light-toned walls and ceiling, plus the bright pages of the book, provided adequate fill and a little accent to their faces. The window to the left of the camera produced the brighter light due to the time of day the image was made.

The mother and child were sitting naturally, as they might had I not been present with a camera. The pillow to the mother's left was a little yellow and had a slight influence on the color balance of the image.

Plate 5.17, an image by Sheila Rutledge, shows another way in which we can pose a mother with her child at her shoulder. This time, the girl is leaning into the portrait from the left edge of the frame and resting her hand and arm on her mother's shoulder. The girl's position caused the mother to tilt her head to our right. The two are cheek to cheek, with the daughter's head slightly higher than the mom's. This created a diagonal line in the composition that produced a dynamic feel in the image.

Sheila's main light was a softbox positioned at a 45 degree angle to the subjects. This produced a 2:1 ratio that slightly increases due to the fact that the mother was slightly turned away from the light. A fill light was used behind and to the left of the camera. Finally, two accent lights were used: one to create

highlights in the girl's hair and another, to camera right and behind the subjects, to highlight the mom's hair.

Michael Ayers captured the portrait in plate 5.18 using reflected window light. As there was no directional light on the subjects, the lighting pattern is relatively flat.

The light used during this session was primarily reflected. The windows in the room provided soft wraparound lighting on the child. Because the mom was turned toward camera left, the window behind her and another a little to camera left made her appear a little more dimensional.

The posing Michael used in the image is very nice. The little girl is shown with her head tipped to lean on her mom's tummy, and she is connecting with the

baby. A nice circular line was formed as a result of the positioning of the subjects' arms, and it easily draws our gaze through the image.

In plate 5.19, we have another image by Michael Ayers. Both the mother and daughter are seated with their hands and arms creating slight diagonals. Their head heights are nicely staggered, and there is a nice implied diagonal line between the subjects' faces.

Michael used his standard setup to light the image. A softbox was positioned at camera left, at 45 degrees

Left—Plate 5.18. **Right**—Plate 5.19.

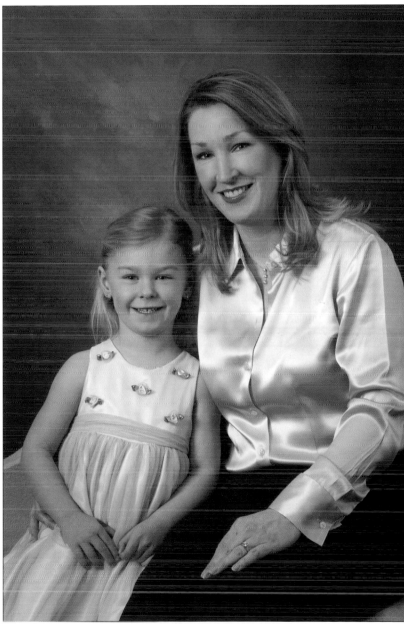

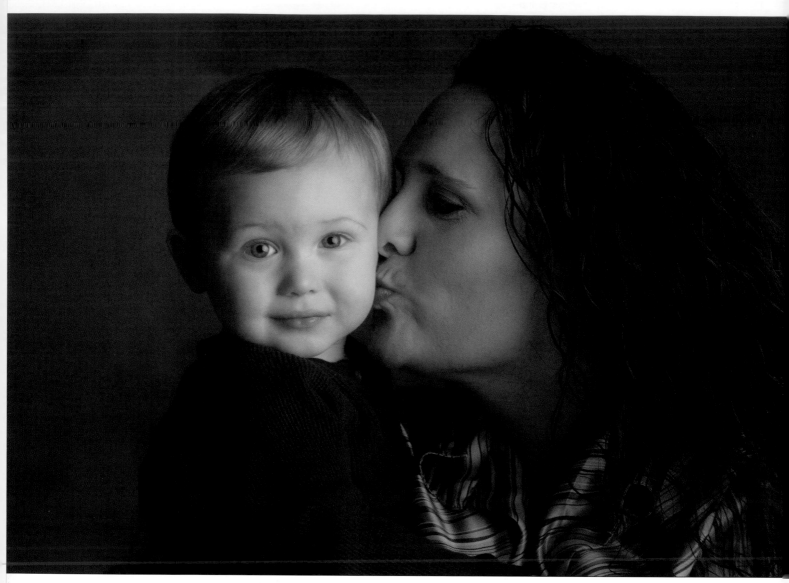

Above—Plate 5.26.

Plate 5.26 (photo by Michael Barton) is a portrait of a mother kissing her child while the child is addressing the camera, perhaps uninterested in his mother's entreaties. The image shows how Michael made great use of one primary light, a double-diffused medium softbox. The unit was placed 40 degrees from his subjects at camera right. The result was beautiful, wraparound light. The catchlights in the boy's eyes add sparkle. The mother was illuminated with beautiful, soft light; we can see this by noting that the shadows from her hair have no hard edges.

A little light was directed at the backdrop to create separation between the boy's dark shirt and the dark-gray backdrop. The portrait, in both concept and lighting, is an example of how simplicity can produce an outstanding portrait. Lighting is not complicated unless we want it to be.

Mothers with Children
Six Years and Older

In theory, our work should become a little easier when our subjects are old enough to understand what we need from them. We'll see, in this chapter, whether this seems to be the consensus of the numerous photographers whose work is profiled here.

Plate 6.1 shows a black & white portrait by Kerry Firstenleit. The mom was aware that the daughter was not cooperating but appears poised and relatively unfazed.

The unique pose that Kerry photographed created an interesting composition. The mom was seated at the right edge of the frame and leaned toward camera left. Her daughter rested her head on her lap. This created a triangular composition that appears to have been rotated a few degrees counterclockwise.

Kerry engaged her subjects from the camera position and was able to capture a little of the child's defiant personality and a lovely expression from the mother.

A double-diffused Westcott Recessed Apollo served as the main light in this portrait. The double diffusion of the light kept it from being too contrasty and allowed detail to be seen in dark and even black fabrics.

Right—Plate 6.1.

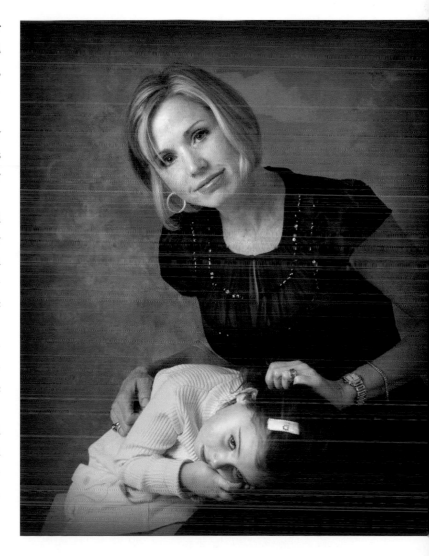

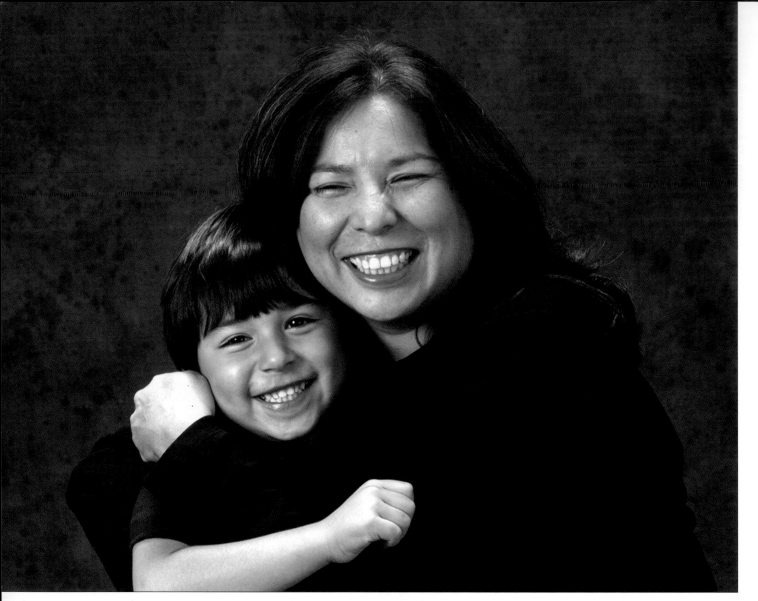

Above—Plate 6.2. **Facing page**—Plate 6.3.

For this reason, a double-diffused softbox is a good lighting choice for many low-key portraits. A reflector was placed near the camera to soften the shadows on the frontal plane of the image. Kerry chose not to use a fill light, so the mom's left arm fell into shadow. As a result, the triangular composition was emphasized, and this focuses more attention on the subjects.

Plate 6.2 shows another Kerry Firstenleit portrait. The posing was simple and natural and allowed the mother and her son to embrace and enjoy the moment. This image is straightforward, with no frills, but the image leaps off the paper and speaks volumes about the playful, loving bond the subjects share.

Kerry used a Westcott double-diffused Recessed Apollo Mono at a little more than 45 degrees off camera left. The subjects' faces were brightly illuminated, and the light allowed for the rendering of detail and texture in the shadows and fabrics. She bounced light from a Westcott Halo Mono off a wall for fill, and a single-diffused Westcott Stripbank was used as a hair light. *(Note:* This is the same lighting setup shown in the diagram on page 42.)

The portrait in plate 6.3 (photo by Michael Barton) presents a different perspective, as the child was positioned over the mother's shoulder, with the mom's back to the camera. The subjects' position allowed

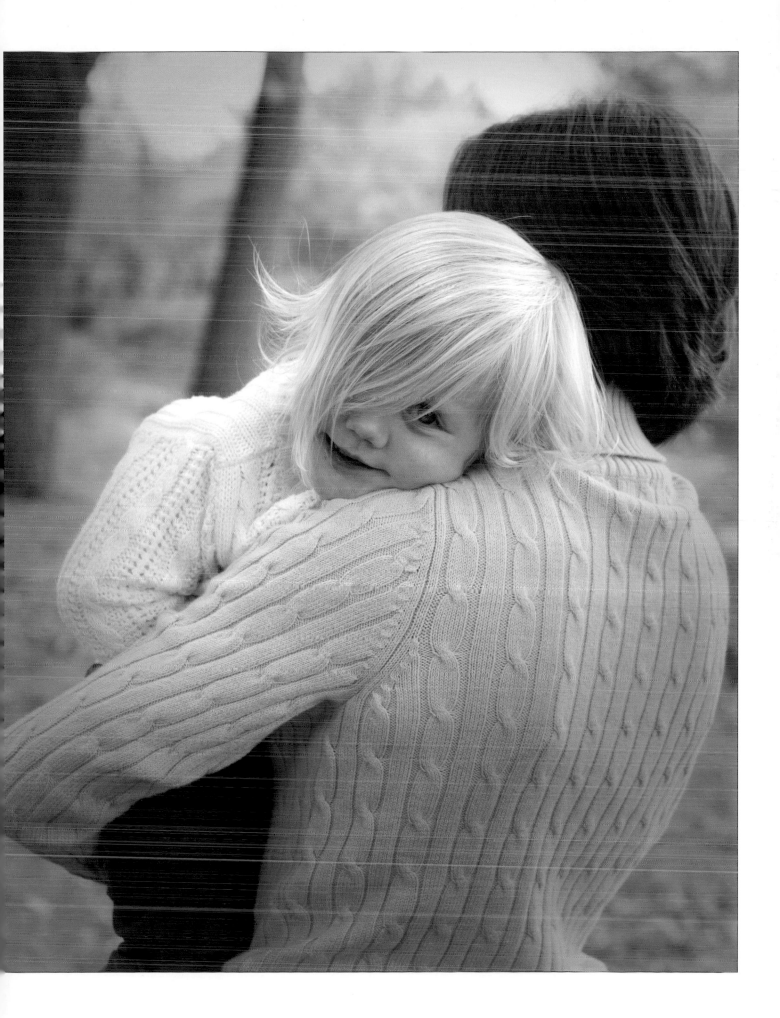

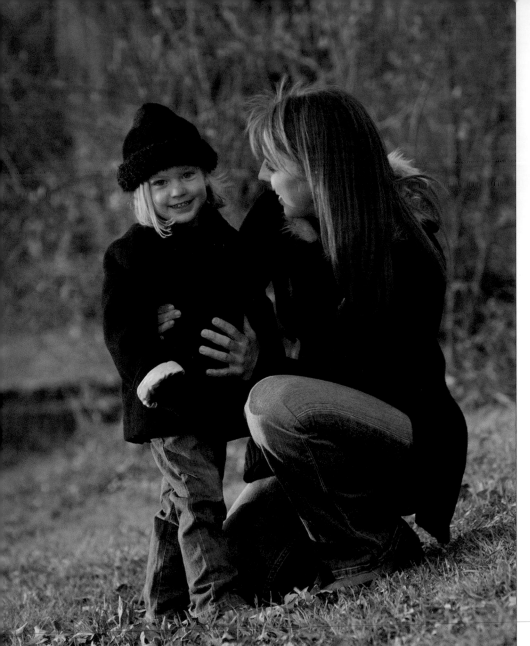

in the hair, and they are in total harmony with the foliage in the background and the grass they are posed on. The warm light on the subjects' jeans adds depth to the image. The tiny, warm highlights on the subjects' faces add depth and vitality. The black coats the subjects wore allowed the multiple colors in the scene to shine through.

Plate 6.5 (photo by Jeff and Kathleen Hawkins) shows a mother and son dressed in black against a white backdrop. The pose and the expressions are very nice, and there is texture visible in the blacks—especially in the boy's sweater. The contrast between the subjects and the background helps to fix the viewer's gaze on the subjects.

Plate 6.6 is another image of the mother and son shown in plate 6.5. This time, Jeff and Kathleen had the subjects switch positions and had the boy posed with his chin tipped downward toward his mom's

filtered sunlight to fall on their hair and the child's face. Michael nailed the exposure, ensuring the child's skin tones were rendered beautifully and detail was captured throughout the image.

This portrait has the artistic merit to stand on its own. However, it would also work well as part of a multi-image presentation that included images in which the mom's face was visible.

The portrait in plate 6.4 (photo by Jody Coss) has numerous delightful elements. The angle of the subjects to the autumn sun created beautiful warm tones

shoulder. The mom has a more direct presentation to the camera, and both subjects have great expressions.

Jeff and Kathleen positioned a softbox to camera left, just beyond 45 degrees off camera. A hair light rendered their hair with good detail. (*Note:* Because the image is in color, there is a greater range of intermediate tones than is available in black & white, so the detail is better rendered in this image.) A reflector was used to soften the shadows, and the background lights provided a little spark at the right side of the image.

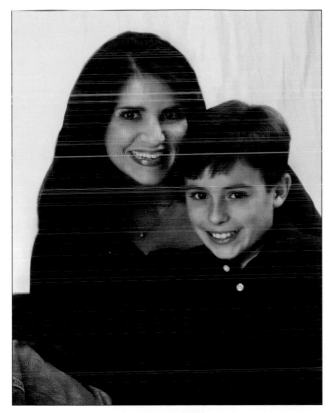

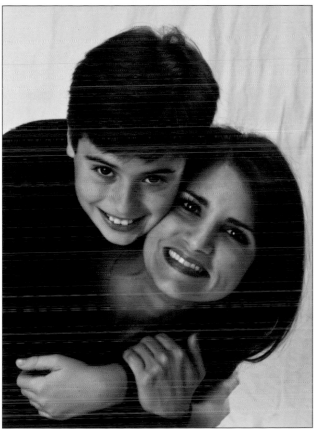

In plate 6.7, Edda Taylor shows us how to use window light to its full potential. She posed her subjects against a white wall adjacent to the wall with the large window. She selected this precise position to achieve the delicate specular highlights on her subjects' faces and to model their features with soft light. The white walls provided subtle fill light on the subjects

The mother was posed square to the camera with her head tipped very slightly and her face turned toward camera left. The girl came in close to the mom's right side and was able to rest her head on her mom's

Top left—Plate 6.5. **Bottom left**—Plate 6.6. **Right**—Plate 6.7.

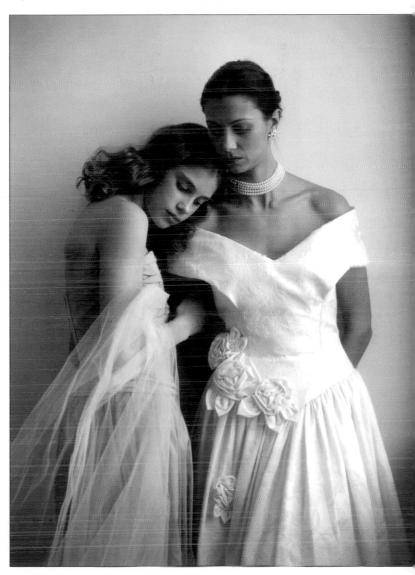

Above—Plate 6.8.

shoulder. The posing, lighting, and well-coordinated clothing combined to produce a beautiful, sensitive, and feminine portrait.

In the image shown in plate 6.8, Mark Laurie reversed a common mother and child pose, presenting the mom in a more submissive position, with her head tipped onto her daughter's shoulder. This works because the child is older. The pose is reminiscent of those moments when family members are taking snapshots of a child and the mother pops into the frame and changes the composition. The difference, of course, is that this is a professional image.

Mark used a 4x6-foot softbox to the right of the camera as a main light. Fill light was produced by a reflector used at camera left, near the camera.

Mothers with Two Children

In this chapter, we will review images of mothers with two children. Some of the images were created in the studio, and others were made on location.

Photographing three subjects requires more guile than working with a mom and one child. Depending on the age of the children involved, we may find ourselves facing some unexpected challenges.

The Michael Ayers portrait in plate 7.1 was created in an all window light setting. The room in which the subjects were photographed had four windows arranged in a semicircle. One window was at camera left, one was at camera right, and there were two windows behind the subjects.

Below—Diagram 7.1. **Right**—Diagram for plate 7.1.

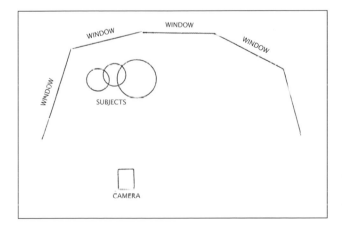

The window light in this scene produced what is called "double lighting" on the subjects. In other words, the lighting pattern on the mother is different

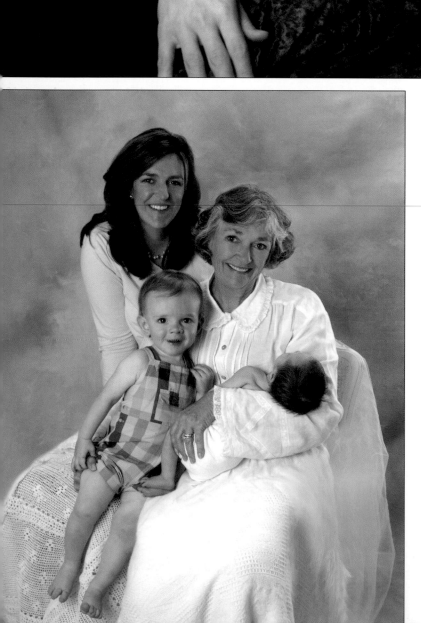

than the lighting pattern on the children. The lighting on the mom is unconventional. Photographers commonly seek to have the subject's face illuminated on one side by the main light. Here, Michael's subject has highlights on both sides of her face, and the ratio we seek to achieve is seen on both cheeks. The lighting on the kids is a little more conventional. Both have highlights on the right side of their face. Because the group was not positioned facing the light source, there are no distinct catchlights in the eyes. See the diagram for plate 7.1 (page 99).

The posing and composition are lovely. There is a wonderful diagonal leading line that runs from the boy on the left of the frame to his mom at the right.

Jody Coss created the portrait shown in plate 7.2 using a low-key set in her studio. The three subjects were attired in dark clothing, in keeping with the low-key portrait concept. The main light was a softbox placed 45 degrees off both camera and subjects. A hair light placed by the background was directed onto their hair.

The posing arrangement Jody used is very attractive, and the mom and older child show a great deal of interest in the new baby.

In plate 7.3, we see a multi-generational image by Terry Jo Tasche. Here, the mother of the children was joined by her own mother for a family portrait.

The posing is casual, and from the grandma's elbow up, the portrait has a lot going for it. There are smiles all around, and there are two nice diagonals—one that runs from the baby to the young mother and one that runs between the toddler and the grandmother.

The lighting on the group came from a softbox positioned at camera left. A light placed behind the camera provided fill.

Michael Ayers is a well-regarded Photoshop artist, and in plate 7.4 we see evidence of his talents. Black & white portraits with selective "handcoloring" are very popular in some markets, and this application is one to consider when presenting images to your clients.

The family group was seated on a porch swing—hence the tight composition. The subjects' arrangement produced a nice diagonal line that leads the viewer to examine the expression on each subject's face. The background elements add a nice touch and do not compete for our attention. The splash of color in the leaves helps to keep our gaze fixed on the focal point of the image.

Michael chose the right location and the right time of day to capture the image. The beautiful, soft sunlight softly modeled the subjects' faces and rendered the ladies in a nice 2½:1 ratio.

The portrait in plate 7.5 is a masterpiece by Edda Taylor. The posing is exquisite and the lighting is simply perfect. There is not a single notion that anything might have been done differently, and certainly not better.

If we analyze the pose, we can see how skillfully it was done. The mother and daughter's placement anchored the pose at the left of the image. They joined hands behind the bouquet with their arms creating a lovely curve from their shoulders to the flowers. The other daughter was tucked into the composition, with the right side of her body behind her mom. In this po-

Top—Plate 7.4. Bottom—Plate 7.5.

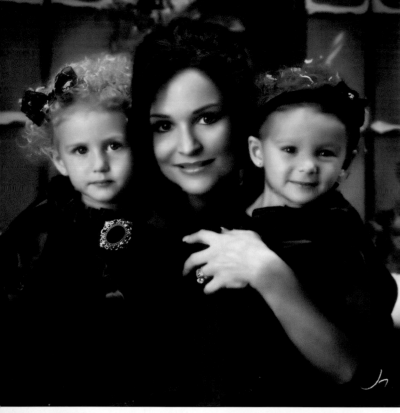

sition, she was able to lightly rest her chin on her mother's shoulder. The posing of her hand on her mom's arm is a nice finishing touch.

The main light for this image was a 4x6-foot softbox at camera left, close to the camera position. A large reflector positioned at camera right produced the fill light. The beautiful lighting produced a delightful range of tones across all elements of the image.

Jeff and Kathleen Hawkins used a low-key set in their studio to create the portrait shown in plate 7.6. The subjects were dressed in black velvet. Their dark eyes are beautiful, and the expressions are all different and intriguing.

The main light was a softbox placed a little more than 45 degrees off camera left. A fill light was also used; it was set to produce half the light that the main light produced. This helped to soften the modeling. Finally, a hair light was set at the same power as the main light. The exposure and lighting were excellent, and the skin tones were beautifully rendered. We can also see nice detail in the hair.

Plate 7.7, a portrait by Michael Ayers, falls into the storytelling category. Michael positioned his subjects at a bay window. He had them turned toward the leftmost window, and this created a different lighting pattern and ratio on each of the faces. The lighting pattern on the boy produced shallow modeling. The lighting pattern we see on the mom is quite flattering, even though she is slightly in the shadow of her son, who was blocking the light coming from the window behind him. The girl was posed in profile and was rendered in a 2:1 ratio.

The light from the window behind the subjects allowed Michael to capture detail in the subjects' hair.

The posing, with the mom at the center and both children posed at an angle to the camera, resulted in a triangular composition that draws the viewer's gaze across the image.

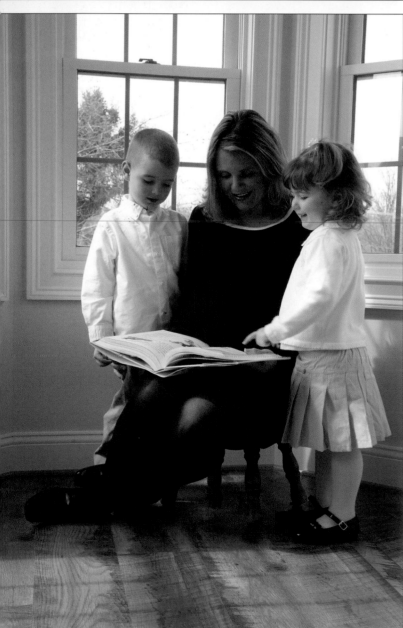

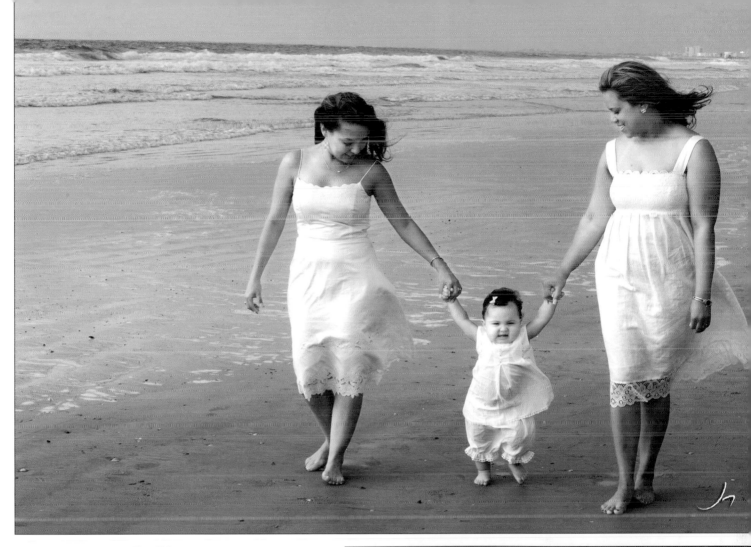

Top—Plate 7.8. **Bottom**—Plate 7.9.

When a child is learning to walk, we are presented with the opportunity to document some special moments with the family, as Jeff and Kathleen Hawkins did in plate 7.8.

The beach was the perfect setting for this image of a mom and her elder daughter holding the infant daughter's hands while she takes some of her first steps. The time of day and the overcast lighting produced the soft modeling on all three subjects. The overcast sky and the sea to the left served as the main light. The sandy beach produced much of the fill light seen in the image.

The composition is nicely balanced with the figures in the right-hand two thirds of the frame.

Plate 7.9 (photo by Norman Phillips) has brought all three subjects tightly together for a nice close-up

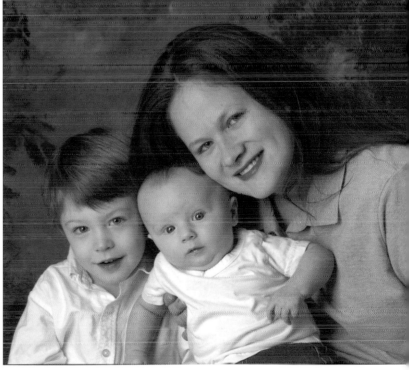

Above—Plate 8.4.

In plate 8.4, a photo by Mark Laurie, we have a beautiful arrangement of a mother and her three daughters. Note how each head was positioned to ensure that no subject's eyes are on the same level as another's. This draws the viewer's gaze across the image. The composition allows us to enjoy each woman separately, in addition to appreciating the role she plays in the group.

A 4x6-foot softbox was placed just to the left of the camera. This served as the main light. A hair light positioned above and slightly behind the group illumi-

nated their hair. A smaller softbox was placed behind the camera and provided fill light. There is a 2:1 ratio in the image. If you look closely at each woman's eyes, you will be able to determine the lighting setup used.

Plate 8.5 (photo by Norman Phillips) was created on a high-key set with a semi-opaque fabric positioned between the subjects and the white sweep. This fabric softened the stark white background and was in keeping with the delicate tones in the composition.

The concept for the portrait was to create an interactive situation by having the two girls at each end of

the composition with the baby as the focal point for the older subjects. We wanted to have the subjects interact with baby and each other and to demonstrate the fascination young children have with newborns.

The dresses the subjects are wearing were borrowed from our studio wardrobe. We stock numerous items that we can fall back on when the subjects are not wearing coordinating clothing. Having some classic, solid-colored garments on hand can save the portrait.

Plate 8.6 shows the same group, with the two little girls investigating their sibling's head and tiny toes. The activity was prompted by asking the little girl on the left to tell us how many toes the baby has and requesting that the other child touch the baby's ear.

Plate 8.7 (page 110; photo by Norman Phillips) was created using only the modeling lamps of the lighting units. It was captured at ISO 650 at 1/30 second handheld. No matter what ISO we choose, the lighting pattern will be the same if we use flash. If we calibrate our modeling lights to that of the flash output, what we see is what we get.

The main light was a single-diffused Westcott Recessed Apollo Mono placed at slightly more than 45 degrees off camera left. The

Top—Plate 8.5. Bottom—Plate 8.6.

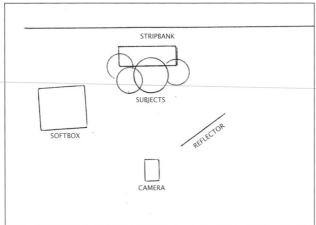

Top—Plate 8.7. **Bottom**—Diagram for plate 8.7.

light was feathered to create the modeling on the subjects. A 12x36-inch, single-diffused Westcott Stripbank was positioned above the subjects, with its front edge level with the center of their heads. A 42-inch white Monte Illuminator reflector was positioned at 45 degrees off camera right. Because the main light was feathered, we were able to bounce adequate light onto the subjects using the reflector. See the diagram for plate 8.7.

The mother was the anchor for this composition. She was seated at 20 degrees off camera. The younger boy kneeled on his left knee so that he could move in close to his mom. The older boy stood behind the bench and rested his left hand on the seat. This brought him close to his mom's head height. The girl was posed with one foot behind the bench and the other at the front of the bench. She leaned onto her mother's shoulder to complete the composition.

When creating portraits for the family, it is always a good idea to create images of the mother and each individual child.

Plate 8.8 (photo by Norman Phillips) was created in the studio with an unlit white background, which was rendered a little blue gray. A single-diffused softbox placed at 45 degrees to camera right served as the main light. A soft-white umbrella was used as a fill light from behind the camera. Finally, an 8x4-foot white reflector panel was positioned to the left of the camera. This produced 2 f-stops less light than the main light and evenly rendered the skin tones.

The mother was seated and held her baby in a natural manner. The older kids were positioned on either side of their mom with one shoulder behind her to ensure a tightly composed grouping. The boy rested his hand on his mom's arm, and the little girl placed her hand to meet her mom's hand. The hands might have been better arranged, but getting the image proved to be a challenge, so what we see is what we got.

Hands play an important role in the portrait shown in plate 8.9 (photo by Vicki Taufer). Vicky had the mom seated with her youngest child in her lap, then had the two boys clasp their hands, which appeared in sharp relief against the black clothing. There is a vertical line comprised of the faces of the daughter, the mom, and the younger boy. The older boy, with the top of his head tipped toward his mom's face, adds a dynamic edge to the image.

Left—Plate 8.8. **Right**—Plate 8.9.

To light the image, Vicky used a softbox placed 45 degrees off both camera and subjects at camera left. This served as the main light. The fill light was positioned behind the camera. Finally, a hair light was positioned above and behind the subjects. With this addition, the light across the composition was perfectly balanced.

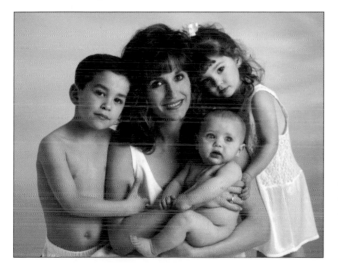

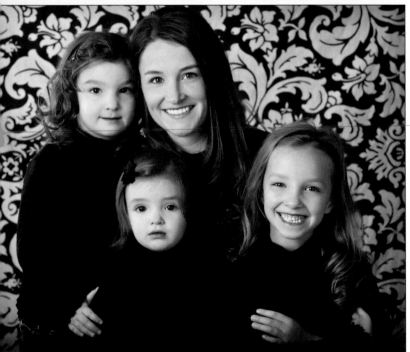

Top—Plate 8.10. **Bottom**—Plate 8.11.

In plate 8.10, we see another striking portrait by Vicki Taufer. This might have been included when we reviewed pregnant mothers with children, but its place here is appropriate. Vicky captured a feeling of innocence and femininity by lighting the subjects relatively evenly with a 2:1 ratio. This allows the subjects' eyes to command our attention.

The main light was a large softbox placed to camera left. The fill light was placed behind the camera. A hair light was positioned almost immediately above the composition.

The posing of the children is very pretty. With each girl posed differently, each shows a unique but innocent impression.

Vicki Taufer has a personal lighting style that is reflected in all of her images, and it is seen in plate 8.11. Note the delicate modeling of the subjects' features.

The ladies were composed in a tight grouping, with the smallest child seated on her mom's lap. The older

girls stood on either side of their mom, and with each subject's head presented at a slightly different height, our eyes easily move through the image.

The casual portrait shown in plate 8.12 (photo by Vicki Taufer) was created using window light that originated from camera left. Because the group was precisely positioned, all four figures are fully illuminated. By observing the light on the floor we can see the group's position in the room. Had they been farther back in the room, the lighting pattern would have more contrast. We cannot see how large the window is, but had the subjects been positioned more toward the camera, the lighting may have been flat with less modeling.

__The grouping is very natural. The mother wrapped her arms around her boys, and the older boy leaned in to rest his chin on his mom's shoulder. All Vicki Taufer had to do was finesse the presentation to get this delightful image.

Plate 8.13 (page 114) shows yet another artfully rendered portrait by Vicki Taufer. The image was created in the client's home, and each of the subjects was posed in an individual style. For this reason, we are presented with a composition made up of several inherently related individual portraits. This is a very interesting concept, and one that we do not see very often.

A window at camera left produced the main light for the image. We can see the slight falloff as the light travels across the group. There is a 4:1 ratio on the girl at the left and (roughly) the same ratio on the mother. The girl in the mom's lap is rendered in a 3:1

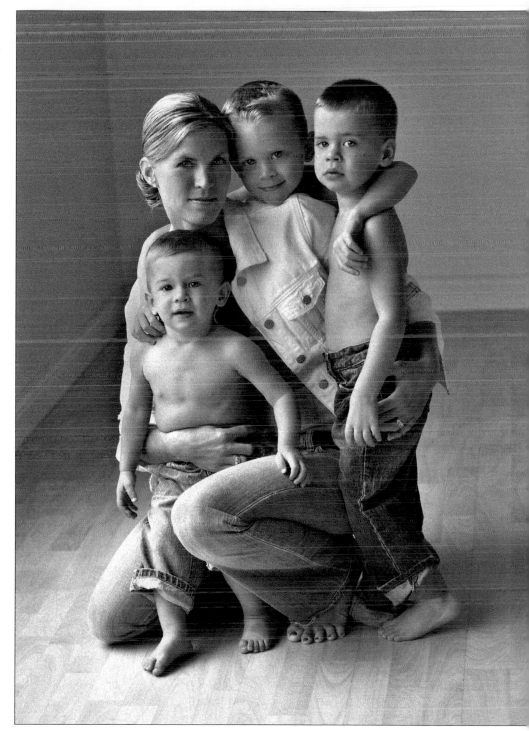

Right—Plate 8.12.

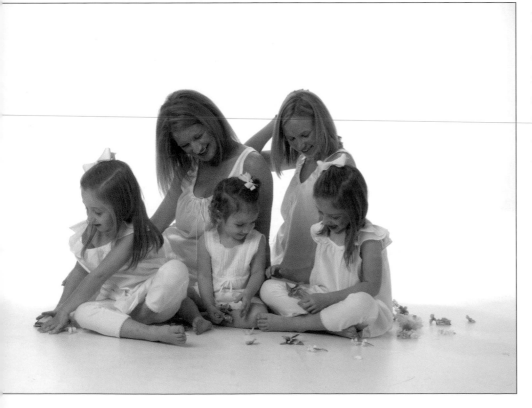

light ratio. The young girl on the right-hand side of the image is rendered with a greater depth of skin tone values.

Plate 8.14 (photo by Norman Phillips) was included as a bonus, as it actually shows a mom with four kids. The image was created on a high-key set with the main light, a 28x42-inch, single-diffused Westcott Recessed Apollo Mono, at 45 degrees off camera left and slightly feathered out. The frontal fill light was from a Westcott Halo Mono bounced off the right-hand wall.

The subjects were posed close to each other and played with the flower petals spread out on the floor in front of them. The three younger children were all seated cross-legged. The mother and the older daughter were seated comfortably behind the younger girls, and their legs were repositioned so that they would not extend beyond the three children at the front of the composition.

Storyboards and Mini Albums

When photographing a mother and her children, we are presented with the opportunity to create images for storyboards or mini albums. Ideally, we will want to select six to twelve images for these products, so you will need to provide an environment in which the subjects' interactions will result in a wide variety of poses and expressions.

Your best bet is to produce a series of images of the mom alone with each of her children, and then to photograph the family group as a single unit.

In the pages that follow, we'll look at some images made to meet these objectives. (*Note:* All images in this chapter were photographed by Norman Phillips.)

WORKING ON LOCATION

The first set of images we will review features a family whose portrait session was held in their home (see page 116). Determining the best area of the home in which to photograph the family was the first order of business. I wanted to use available light, and the family's living room had three windows, making it an ideal choice.

The window to the right of the camera provided the greatest light intensity and served as the main light. The window at the left of the room was a little farther from my subjects; it produced the fill light, in conjunction with the ambient light that was reflected off of the light-colored walls. Behind the group was a shuttered window that reflected additional light into the set. Finally, because the subjects were asked to wear white clothing for the session, their attire also provided a little bit of reflected light. See the diagram for plate 9.1 (page 116).

We began the session by photographing the mother and her two daughters. The mom was seated on her couch and turned to present a flattering profile. In this position, the light from the windows would illuminate her beautifully. Her older daughter was seated next to her and turned to present a three-quarter facial presentation. In this position, the natural light would produce a pleasant rendering. Finally, the younger girl was positioned next to her sister. The light reflected from the subjects' clothing produced an acceptable lighting pattern. If she were photographed alone, the lighting pattern obtained would be unacceptable, but based on the concept, the lighting worked well enough.

We used a book to create a point of focus for the subjects and a base for the composition. The ladies' arms run along the bottom of the portrait, visually linking the subjects. The mother and younger child

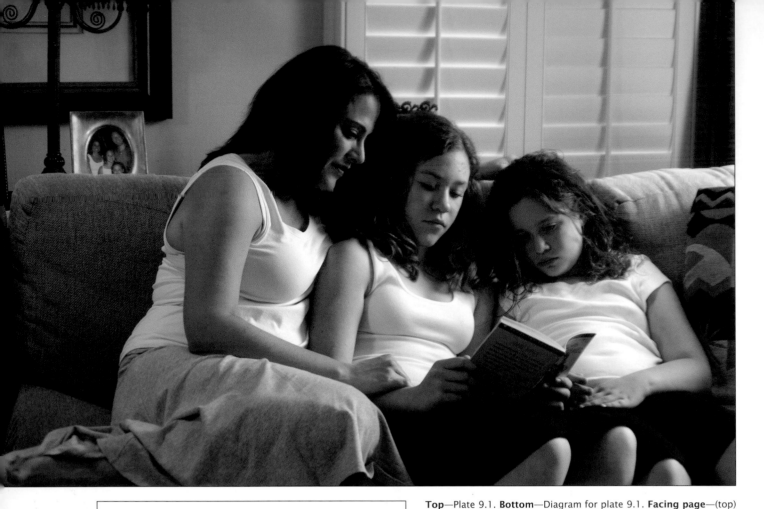

Top—Plate 9.1. **Bottom**—Diagram for plate 9.1. **Facing page**—(top) Plate 9.2. (bottom) Plate 9.3.

were coached to lean toward the center to bring their heads close. This created a nice diagonal from the mom's head to the younger girl's head. See plate 9.1.

We used the same set to create the portrait of the mom and her older daughter shown in plate 9.2. Only one adjustment was made to the previous approach: we had the girl turn toward her mom so that their heads and shoulders touched. This produced a triangular composition.

This modification in the subjects' position slightly changed the mother's profile presentation, but the sculpted modeling shown in plate 9.1 was maintained. The change also modified the lighting pattern on the girl's face. The window to the left and light reflected from the white attire beautifully rendered her face.

In plate 9.3, we have a third image option. Here, the mother is joined by her younger daughter.

For this portrait, the camera position was changed to bring the subjects together in a closer pose. As a result of the modification, we produced a different and more attractive lighting pattern on the girl's face. The new camera angle changed our view of the mother, presenting her face in shadow. The posing shows a close bond between the subjects.

After producing the first three images, we had the subjects change into their nightclothes. The ladies

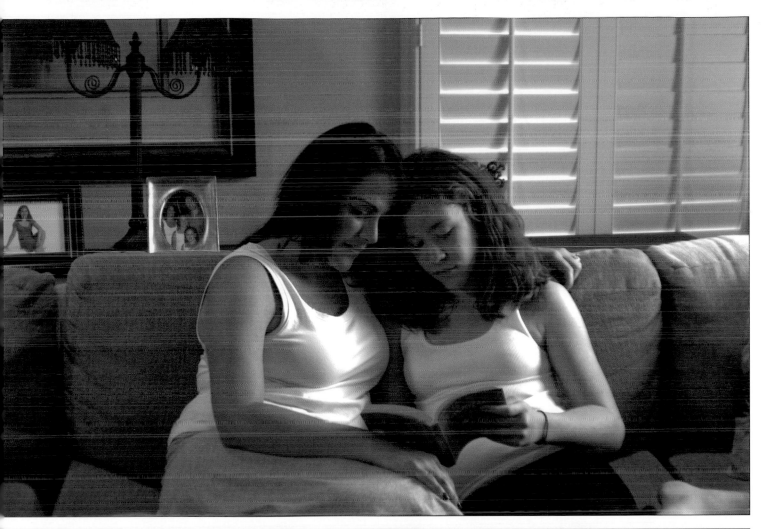

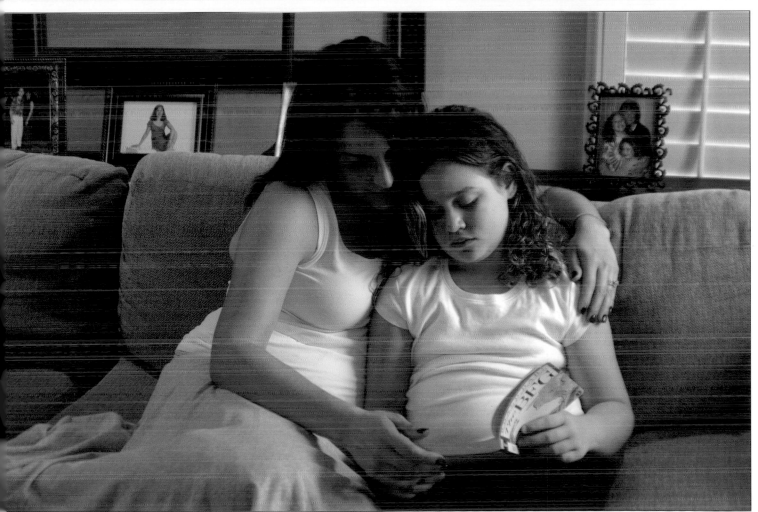

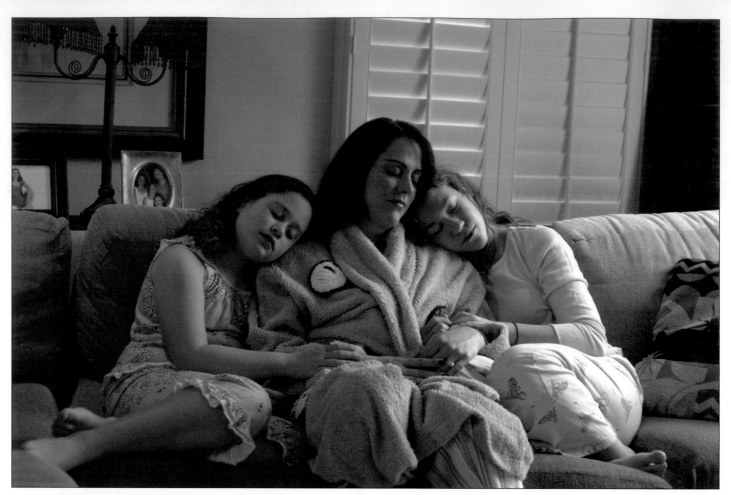

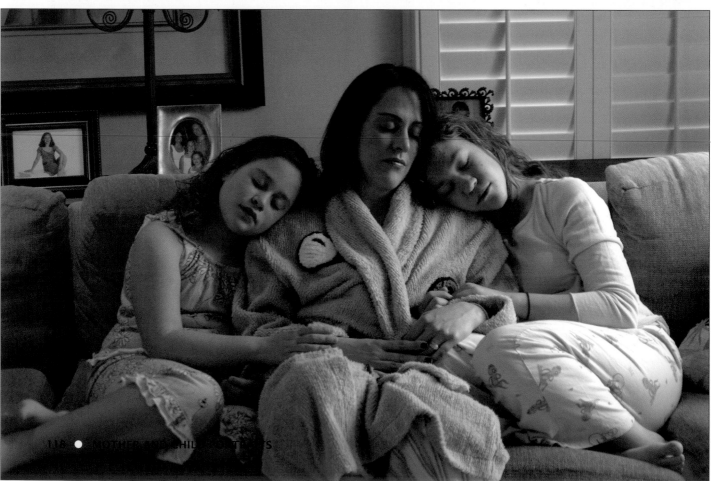

Plate 9.6.

Plate 9.7.

Plate 9.8.

Plate 9.9.

were again posed on the couch, and this time, our goal was to photograph them relaxing. The camera angle in this image was the same as it was in the first image we reviewed. See plate 9.4.

To create the image shown in plate 9.5, we changed the camera angle. Because the lighting came from the windows in the room and therefore could not be moved, the change in the facial presentations resulted in altered lighting on the faces.

Note how the subjects' arms once again form a base for the composition and link the subjects, illustrating their close bond.

With this image complete, we turned our attention to capturing images of the subjects interacting naturally and enjoying each other's company. We see the results in plates 9.6–9.9.

To finish the session, we created the image shown in plate 9.10. We wanted to create a portrait of the three subjects with a more serious or thoughtful mood.

Plate 9.10.

The images presented here are only a handful of those created during the session. When we review these images, we can see the potential for multiple sales that may include folios, storyboard presentations, and mini albums as well as wall portraits—a complete package.

IN THE STUDIO

The following images were created on a high-key set in the studio. In these examples, we see a variety of compositions and poses that would beautifully lend themselves to inclusion in a storyboard or mini album.

In plate 9.11, we see the first image in this series. Because the youngest child needed his mother's support, he was seated on his mom's left leg, with his mom's arm around him to keep him stationary. The older boy was seated on his mom's knee as well. This served a dual purpose: it brought him close to his mom for the portrait and kept him from running around the set!

For the portrait in plate 9.12, we have a different and better-designed composition. The little one was placed between his mother' legs, which were posed to create a landscape composition. The older boy is now alongside his mother and under her control, and we have a nice portrait.

Plate 9.13 shows a slight variation on the pose shown in the previous image. Here, both boys were kept in position using the mom's legs as a barrier.

Plate 9.11.

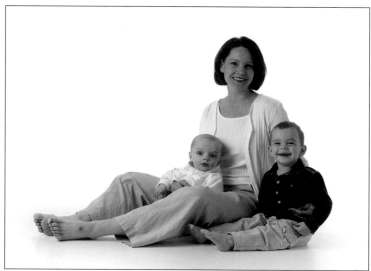

Plate 9.12.

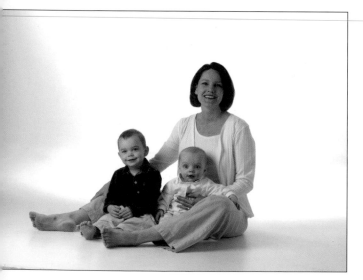

Plate 9.13.

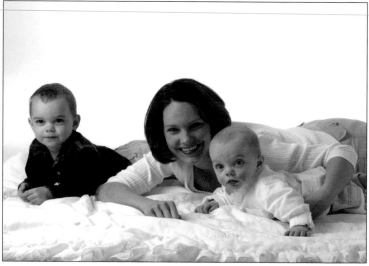

Plate 9.14.

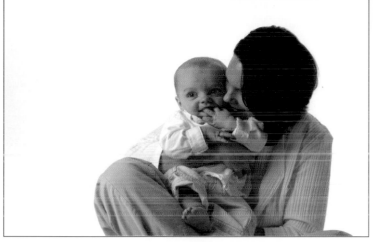

Plate 9.15.

Plate 9.16.

Plate 9.17.

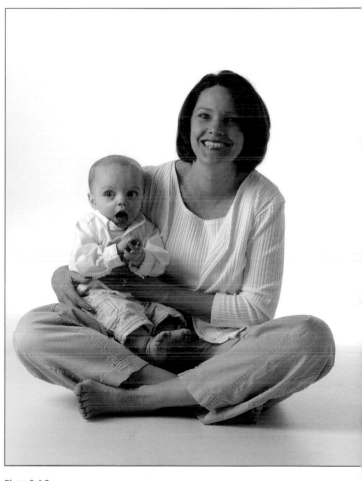

Plate 9.18.

Yet another arrangement was created for plate 9.14. This time we posed the subjects on the floor for a potential "slim Jim" presentation, the type of image that can be a long and relatively narrow framed wall portrait. Note that the subjects are not cramped, so the compositions fit the concept of the potential sale.

After completing the portraits of the trio, we moved on to create the two-subject groupings. We began with the younger child, as there was a good possibility that he would tire as the session wore on. See plates 9.15–9.18.

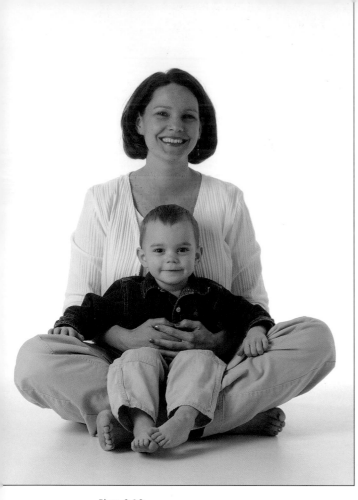

Plate 9.19.

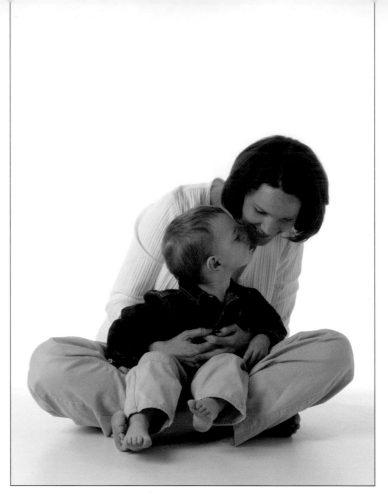

Plate 9.20.

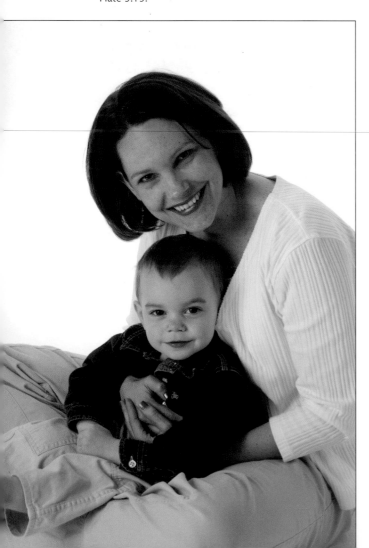

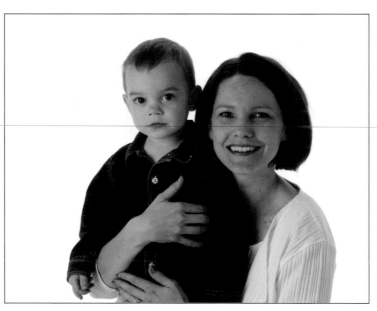

Left—Plate 9.21. **Right**—Plate 9.22.

Next, we photographed the mother with her elder son. In plate 9.19, we have the boy seated between his mother's legs, which are arranged in a pretzel position. We rested his arms on his mother's knees, and she held onto him to keep him in the desired position. It is a fun arrangement and was a good starting point.

Plate 9.20 shows a simple variation of the previous pose. We simply captured the boy moving in to give his mom a kiss.

Next, we rotated the pair 45 degrees toward camera left. This allowed for the more flattering presentation of the mother shown in plate 9.21.

For the final image in this series, plate 9.22, we decided to present the little boy standing. He stood with his feet planted between his mom's legs, allowing the mother to wrap her arms around him in a loving pose. When standing, the boy's head height was similar to his mom's. His expression in this image is quite different from the others we have seen, but the mother once again smiled.

A CHANGE OF PACE

In the reception area of our studio we have a large window that beautifully illuminates the room. We often use this room in our sessions.

Our final images, plates 9.23 and 9.24, show the mom attempting to read her boys a story. As you can

Top—Plate 9.23. **Bottom**—Plate 9.24.

see here, the older boy was irrepressible and largely did his own thing while interacting with his mom and brother. The younger boy was occupied doing the things that toddlers do.

Other than placing the baby boy at the left and his brother at the right, no posing was done. We simply let the children interact naturally with their mom. Plate 9.24 is my favorite, as it shows the mom laying down some ground rules. The images tell their own story.

Conclusion and Credits

The images reviewed in this book have provided us with a wealth of ideas as to how we may create portraits of mother and child. Each image presented had a distinct style or a nuance that made it different from an image that might have appeared similar. By examining the portraits and considering the way they were created, we have learned lessons that we can use time and again when working with our clients.

There is no one way to do anything in photography, as each of us sees things differently. What we do as individual practitioners is dependent upon our individual sense of light and composition. We cannot copy images by our colleagues, but we can learn from them and be inspired.

In studying the images in this book, though, we can see some common characteristics among successful images. We have learned that single-diffused softboxes are the preferred choice as the main light, and softboxes are consistently used as fill light sources. We have also discovered that most of the photographers profiled in these pages prefer a light ratio of 3:1. Few photographers whose work appears here used a lower ratio. We have seen a few examples of images created with a 4:1 lighting ratio; they have been striking and have broken the proverbial mold.

We should note too that most of the images selected for inclusion in the book fall into the category of middle key. However, we have also seen evidence that some photographers prefer to work primarily in low key or high key and that their choice has helped them to develop their signature style.

The diversity of images included in this book offers many options for those who have not yet decided on a style or signature lighting. I recommend that you review the images several times and get a feel for what affects your senses. If we are to be successful, we not only need to be technically proficient but must properly represent our emotions. If we don't, we will not be excited at each session, and our work will be average at best.

Good luck on your journey.

ABOUT THE AUTHOR

Norman Phillips is the author of numerous books from Amherst Media, including *Lighting Techniques for High Key Portrait Photography, Lighting Techniques for Low Key Portrait Photography,* and *Master Posing Guide for Children's Portrait Photography.* He has created nearly 260 images that have earned a score of 80 or better in print competition and has won numerous Best of Show ribbons and First Place Awards in various competitions.

ABOUT THE CONTRIBUTORS

Joanne Alice. Joanne is the recipient of four Best of Show Awards from Chicagoland Professional Photographers Association and is a four-time recipient of CPPA's Print of the Year Award. She has earned the CPPA Certified Professional Photographer designation.

Michael Ayers (www.theayers.com). Michael has a PPA Master Photographer degree and is a PPA Certified Professional Photoghrapher. He was named WPPI's International Photographer of the Year and presents programs to photographers worldwide.

Michael Barton (www.indigophotographic.com). Michael is a PPA Certified Photographer and has earned PPA's Photographic Craftsman degree. He has a fellowship with Professional Photographers of Northern Illinois

Veena Cornish (www.veenacornish.co.uk). Veena is a licentiate with the Society of Wedding and Portrait Photographers and a frequent winner of professional competitions. She has a thriving portrait studio in Lincolnshire, England.

Jody Coss (www.hillsidestudio.com). Jody is a PPA Certified Professional Photographer.

Kerry Firstenleit. Kerry joined my studio, Norman Phillips of London, in 1996. Since joining the studio, she has received awards for her portrait and wedding work and has a number of accolades (prints scoring 80 or better) from WPPI.

Sarah L. Johnston (www.sjohnstonphotography.com). Sarah has a Master Photographer and Photographic Craftsman degree from PPA. She is a PPA Certified Professional Photographer and has a fellowship with Professional Photographers of Northern Illinois.

Jeff and Kathleen Hawkins (www.jeffhawkins.com). Jeff and Kathleen have written eight books for Amherst Media. Jeff is a PPA Certified Professional Photographer and holds the PPA Craftsman degree. Kathleen is the recipient of the PPA AN-NE Award for marketing excellence.

Mark Laurie (www.marklaurie.com). Mark is an internationally recognized photographer with a fellowship with Britain's Society of Wedding and Portrait Photographers, a Master of Photographic Arts, and a Service of Photographic Arts. His work is displayed at the Epcot Center, Hungarian National Cultural Center, the Calgary Stampede, and in London's International Hall of Fame.

Cindy Romano (www.cromanophotography.com). Cindy has a PPA Masters degree, is a PPA Certified Professional Photographer and a PPA Affiliate Judge. She has produced four PPA Loan Collection prints and has had images displayed at Epcot Center.

Sheila Rutledge (www.capturedbysheila.com). Sheila is a PPA Certified Professional Photographer and has a fellowship with Professional Photographers of Northern Illinois. She is also the vice president of the association.

Terry Jo Tasche (www.terrytasche.com). Terry Jo has a PPA Master Photographer degree, a PPA Photographic Craftsman degree, and a fellowship with Professional Photographers of Northern Illinois.

Vicki Taufer (www.vgallery.net). Vicki is one of the country's most admired and accomplished photographers. Her studio, V Gallery, is regarded as a leader in the industry. She is also in demand as a speaker.

Edda Taylor (www.eddataylor.com). Edda's unique style and approach to photography have won her national and international acclaim, including the prestigious Gerhard Bakker Memorial Award and Kurt Lieber Gold Award. She has lectured throughout the United States and Europe. Edda holds PPA's Master Photographer and Photographic Craftsman degrees.

Wendy Veugeler (www.cellarportraitstudio.com). Wendy holds a PPA Masters degree and is a PPA Certified Photographer. She also has a fellowship with Professional Photographers of Northern Illinois. She is the recipient of the Kodak Gallery Award, Fuji Masterpiece Award, and PPA Photographer of the Year Award.

Index

OTHER BOOKS FROM

Amherst Media®

PROFESSIONAL POSING TECHNIQUES FOR WEDDING AND PORTRAIT PHOTOGRAPHERS

Norman Phillips

Master the techniques you need to pose subjects successfully—whether you are working with men, women, children, or groups. $39.95 list, 8.5x11, 128p, 260 color photos, index, order no. 1810.

MASTER POSING GUIDE FOR CHILDREN'S PORTRAIT PHOTOGRAPHY

Norman Phillips

Create perfect portraits of infants, tots, kids, and teens. Includes techniques for standing, sitting, and floor poses for boys and girls, individuals, and groups. $34.95 list, 8.5x11, 128p, 305 color images, order no. 1826.

THE ART OF CHILDREN'S PORTRAIT PHOTOGRAPHY

Tamara Lackey

Learn how to create images that are focused on emotion, relationships, and storytelling. Lackey shows you how to engage children, conduct fun and efficient sessions, and deliver images that parents will cherish. $34.95 list, 8.5x11, 128p, 240 color images, index, order no. 1870.

50 LIGHTING SETUPS FOR PORTRAIT PHOTOGRAPHERS

Steven H. Begleiter

Filled with unique portraits and lighting diagrams, plus the "recipe" for creating each one, this book is an indispensible resource you'll rely on for a wide range of portrait situations and subjects. $34.95 list, 8.5x11, 128p, 150 color images and diagrams, index, order no. 1872.

THE ART OF PREGNANCY PHOTOGRAPHY

Jennifer George

Learn the essential posing, lighting, composition, business, and marketing skills you need to create stunning pregnancy portraits your clientele can't do without! $34.95 list, 8.5x11, 128p, 150 color photos, index, order no. 1855.

MASTER LIGHTING GUIDE FOR PORTRAIT PHOTOGRAPHERS

Christopher Grey

Efficiently light executive and model portraits, high and low key images, and more. Master traditional lighting styles and use creative modifications that will maximize your results. $29.95 list, 8.5x11, 128p, 300 color photos, index, order no. 1778.

ON-CAMERA FLASH TECHNIQUES FOR DIGITAL WEDDING AND PORTRAIT PHOTOGRAPHY

Neil van Niekerk

Discover how you can use on-camera flash to create soft, flawless lighting that flatters your subjects—and doesn't slow you down on location shoots. $34.95 list, 8.5x11, 128p, 190 color images, index, order no. 1888.

MORE PHOTO BOOKS ARE AVAILABLE

Amherst Media®
PO BOX 586
BUFFALO, NY 14226 USA

INDIVIDUALS: If possible, purchase books from an Amherst Media retailer. Contact us for the dealer nearest you, or visit our web site and use our dealer locater. To order direct, visit our web site, or send a check/money order with a note listing the books you want and your shipping address. All major credit cards are also accepted. For domestic and international shipping rates, please visit our web site or contact us at the numbers listed below. New York state residents add 8.75% sales tax.

DEALERS, DISTRIBUTORS & COLLEGES: Write, call, or fax to place orders. For price information, contact Amherst Media or an Amherst Media sales representative. Net 30 days.

(800)622-3278 or (716)874-4450
Fax: (716)874-4508

All prices, publication dates, and specifications are subject to change without notice.
Prices are in U.S. dollars. Payment in U.S. funds only.

WWW.AMHERSTMEDIA.COM
FOR A COMPLETE CATALOG OF BOOKS AND ADDITIONAL INFORMATION